NORTH CAROLINA'S *Wild* PIEDMONT

A NATURAL HISTORY

Adam Morgan

THE
History
PRESS

Published by The History Press
Charleston, SC 29403
www.historypress.net

All images are by the author.

First published 2015

Manufactured in the United States

ISBN 978.1.62619.777.0

Library of Congress Control Number: 2015942731

Notice: The information in this book is true and complete to the best of our knowledge. It is offered without guarantee on the part of the author or The History Press. The author and The History Press disclaim all liability in connection with the use of this book.

For Erin—who married me on one of these gently rolling hills—and for Mom, Dad and Alex.

CONTENTS

CONTENTS

Acknowledgements

Without the following family members, friends and colleagues, this book would have never been possible. Thanks to my wife, Erin, for her encouragement and patience. Thanks to my mother, Debbie, and my father, Steve, for taking me hiking and fishing as a child at Crowders Mountain and all over North Carolina. Thanks to my brother, Alex, for accompanying me on so many excursions, including that time we didn't make it off Standing Indian Mountain until after sunset, prompting Mom to call Search and Rescue (we're still sorry about that). And thanks to my dog, Sadie, for joining me on some hikes and staying home alone on others.

Thanks to all the park rangers, superintendents, scientists and outdoors enthusiasts who shared their stories and expertise with me: Larry Hyde at Crowders Mountain State Park, as well as Bob Bigger and Fred and Kay Moss in Gastonia; Keith Nealson, superintendent of Eno River State Park, and ranger Mary Griffin; Greg Schneider, superintendent of Morrow Mountain State Park; Jeff Davidson, superintendent of Raven Rock State Park; Jeff Bricken, Wildlife Refuge manager at Pee Dee National Wildlife Refuge; Steve McMurray, park ranger at Jordan Lake; Jason Anthony at Hanging Rock State Park; and Bob Davies and Brian Bockhahn at Falls Lake; David Robinson, Steve Copulsky and Cassie Gavin at the North Carolina Chapter of the Sierra Club; Rick Gaskins, executive director of the Catawba Riverkeeper Foundation; Liz Stabenow, education director at the Eno River Association; and Dr. Martha Cary Eppes, professor of earth sciences at the University of North Carolina–Charlotte.

ACKNOWLEDGEMENTS

Thanks also to my writing mentors, Scott Blackwood, Owen Egerton and Lisa Williams, as well as my editor, J. Banks Smither, and his wonderful colleagues at The History Press.

INTRODUCTION

Much happens in the meadow;
it is a stage for fervent activity and a theatre of war.
—*Leena Krohn,* Tainaron: Mail From Another City

There are more stories in a single acre of forest than in the entirety of Norse or Greek mythology. To the untrained eye, this acre may appear unremarkable—a modest array of trees and leaf litter, the stuff of desktop wallpapers and TV ads for allergy medications.

But in the same acre, a naturalist sees centuries-old sagas of death and rebirth. A naturalist sees young oak trees beneath a canopy of pines and knows the forest is only a few decades removed from a serious ecological or man-made disturbance. A naturalist sees a brown-headed cowbird leaving the crook of a tree branch and knows it may have just abandoned an egg in the nest of another bird, preferring to avoid the responsibilities of parenthood. A naturalist sees an amanita mushroom huddled at the base of an oak and knows the fungus beneath the earth is providing the tree with decomposed nutrients, while the roots of the oak provide the fungus with the sugar it photosynthesized in its leaves.

The purpose of this book is to help you cultivate a new kind of literacy, to see what Tennessee biologist David George Haskell calls "The Forest Unseen" and to deepen your understanding of the North Carolina Piedmont's natural history and present-day ecology at two dozen sites.

While millions of hikers, campers, birders and other seekers of wild places visit North Carolina's mountains and coastal plains every year, the Piedmont

is often the state's neglected middle child. As a region, the Piedmont is probably best known as the epicenter of New South urbanization (the Charlotte, Triad and Triangle areas), but it's also home to eleven state parks, three state recreational areas, three state natural areas, a national wildlife refuge and a national forest. And yet, its natural beauty is rarely celebrated in literature or travel guides, and the natural history of its wild spaces is often tucked into a larger book that dedicates most of its pages to the mountains and the coast.

But let me be clear. *North Carolina's Wild Piedmont: A Natural History* is *not* a trail guide. You'll find plenty of those in bookstores and outdoors outfitters throughout the state. This book is *not* a reference guide to the activities and amenities available at North Carolina's state parks and recreation areas. You can find that information online or in Lynch and Pendergraft's beautiful *North Carolina State Parks: A Niche Guide.*

Instead of a directional guide to the region's trails, this book is like taking a guided tour of the region with a naturalist. While trail and reference guides are valuable and essential to trip planning, this book is a series of nature essays that combine natural history; field research; interviews with academics, park superintendents and park rangers; and my own firsthand experience in the Piedmont in an attempt to answer a series of questions about each site. Questions like:

How did the landscape form?
How have natural processes changed the landscape over the past few million years?
How has human activity impacted the landscape over the last few hundred years?
What kinds of geological and ecological features will I find?
What kinds of flora and fauna will I find?
What distinguishes this site from the others?
Why is it worth experiencing and protecting?

This last question is particularly relevant in the twenty-first century. While North Carolina's wild spaces are some of the most beautiful in the United States, their delicate ecosystems are currently facing major threats—particularly in the Piedmont, where the vast majority of North Carolinians live and work, and where the natural resources aren't as widely celebrated as those in the mountains or on the coast. Specifically, the Piedmont's remaining pockets of wilderness are threatened by new legislative policies, encroaching urban sprawl, invasive species and decreased funding.

"Historically, North Carolina hasn't been opened up to fossil fuel development," says Cassie Gavin, director of government relations at the North Carolina Chapter of the Sierra Club in Raleigh, referring to states like Texas, Colorado, Wyoming and Pennsylvania with huge oil and natural gas operations. "But that's changing under the current governor [Pat McCrory] and legislature. In 2014, they opened up the state to fracking."

Fracking is short for hydraulic fracturing, where natural gas drills pump massive amounts of chemicals into the ground to break up fossil fuel deposits. These chemicals—including kerosene, formaldehyde, benzene, toluene and xylene—can contaminate groundwater and surface water, not to mention their methane emissions. And in 2013, the Centers for Disease Control testified to Congress that the Environmental Protection Agency had documented fracking contamination at several sites. In the same year, a majority of North Carolinians said they opposed fracking in a poll conducted by the Natural Resources Defense Council.

Nonetheless, the following year Governor McCrory signed the innocently named Energy Modernization Act into law, opening up North Carolina to fracking. "There was a proposal in North Carolina last year for fracking right next to a state park," Gavin says. "We used to be one of the most progressive states in the Southeast in terms of protecting natural resources and developing alternatives to fossil fuels, but that doesn't appear to be the case anymore. The North Carolina coast has some of the best wind resources in the country, but there's been no interest from lawmakers in developing that. There's been no focus on solar energy either."

The encroachment of urban sprawl is another concern in the Piedmont, home of some of the fastest-growing cities in the United States. Superintendent of Morrow Mountain State Park (see chapter 11) Greg Schneider is starting to feel the pressure of that sprawl an hour east of Charlotte. "Folks realized Stanly County's a wonderful place to live, so we've got a lot of development going on right outside the park. The views are starting to change, and we haven't been able to create any buffer zones to protect those viewsheds and natural resources." Brian Bockhahn, interpretation and education specialist at Falls Lake (see chapter 16), agrees. "Surrounding land use has changed dramatically over the years, with development now right up against park boundaries in most cases."

Invasive species of flora and fauna can be just as destructive as man, from the southern pine beetles that decimated trees at Lake Norman State Park (see chapter 8) to the rampant kudzu choking native plants across the Southeast. "The number one ecological threat to Eno River State Park,"

says Superintendent Keith Nealson, "is the spread of the invasive aquatic weed known as hydrilla."

Hydrilla is an underwater weed that often clumps at the surface of infected bodies of water. It was dumped into rivers in Florida by aquarium dealers in the 1950s. Since then, hydrilla has spread across the country, killing hundreds of native species and costing millions of dollars every year. Liz Stabenow at the Eno River Association says hydrilla is "crowding out our native plants, making it hard for native game fish like white bass to survive and encouraging the growth of toxic blue-green algae that can threaten local birds. Methods of controlling it are being tested, but these, too, may have negative impacts on the river."

And hydrilla is just one of many invasive plants wreaking havoc in the Piedmont. "Other terrestrial and aquatic species threatening the Eno River include alligatorweed, parrotfeather, microstegium, tree-of-heaven, privet and bamboo," says Superintendent Nealson.

Finally, the financial state of North Carolina's park system has seen better days. "I think we're forty-eighth in the nation for state park funding," says Gavin, "and yet North Carolina's parks are some of the country's most visited." Morrow Mountain and Hanging Rock, two of the oldest parks in the state, suffer from crumbling infrastructure. Almost every superintendent and ranger I spoke with over the past year is suffering from cost-cutting measures instituted by the state. "I'm authorized four rangers and myself, but I've been a ranger short for the past three years, and one of the ones I do have has a broken foot," says Schneider at Morrow Mountain. "I spend a lot of my time outdoors, even though sometimes I'd be better served in my office, just because we're so short-staffed."

But funding issues aren't limited to state parks. "The biggest single threat to the National Wildlife Refuge System are the continuous budget cuts that are taking place each year," says Jeffrey Bricken, manager of the Pee Dee National Wildlife Refuge (see chapter 20). "Just a few years ago, we had eight full-time employees. Now we only have three. And we're trying to manage 8,500 acres, thirty miles of roads and levees and a visitor population of fifty thousand people a year."

I've spent more of my life in the Piedmont than anywhere else on earth, and I've explored all of the sites in this book. However, as a writer—not a scientist—I'm indebted to the giants on whose shoulders *North Carolina's Wild Piedmont* stands, particularly Kevin G. Stewart and Mary-Russell Roberson's *Exploring the Geology of the Carolinas*, Michael A. Godfrey's *The Piedmont: A*

Sierra Club Naturalist's Guide, Edward J. Kuenzler's *Time and the Piedmont* and *Exploring North Carolina's Natural Areas*, edited by Dirk Frankenberg, as well as my colleague at the University of North Carolina–Charlotte, Associate Professor of Earth Sciences Dr. Martha Cary Eppes.

I'm also indebted to the mythographers James Mooney and Joseph Campbell, as well as J.R.R. Tolkien, Simon Schama, Jeff VanderMeer and David George Haskill, who provided me with some of the lenses through which I see the natural world.

Whether you're a hiker, camper, angler, hunter, paddler or naturalist, this book will deepen your understanding of the Piedmont's natural treasures. And when you visit any of the beautiful places described within, you'll be familiar with their ongoing stories on scales both great and small.

PART I

An Overview of the Region

Chapter 1

WHAT IS THE PIEDMONT?

Piedmont land was red and coarse, often covered with tough oaks and hickories…the people who took up land here were not often tempted to acquire more than could be tilled by one man and his sons. The piedmont, therefore, evolved into a land of small, independent farmers.
—*William S. Powell,* North Carolina: A History

Ask any middle school student in North Carolina what the Piedmont is, and they won't hesitate: it's the middle part of the state, between the Mountains and the Coastal Plain. Most North Carolinians will have similar definitions, including the state tourism board, whose map of the Piedmont begins in Hickory and ends in Raleigh.

Ask Google, and you might see the eastern two-thirds of the state further subdivided into four sub-regions—the Foothills, Piedmont, Inner Coastal Plain and Outer Coastal Plain—based on changes in elevation. You might also see maps of North Carolina where the "big three" regions have been drawn right down county lines.

Ask a geologist or an ecologist the same question, and you'll get a more nuanced answer. Technically, the Piedmont begins at the feet of the Blue Ridge Escarpment and stretches two hundred miles or so east until it ends at the Fall Line.

The western boundary of the Piedmont—the Blue Ridge Escarpment— is a dramatic, state-spanning series of cliffs and mountains where the easternmost peaks and bluffs in the Blue Ridge Mountains suddenly

drop one thousand to two thousand feet to the Piedmont plateau below. Beginning near Tryon, North Carolina, at the South Carolina border, the North Carolina section of the escarpment snakes all the way up to the town of Lowgap near Virginia. The drastic change in elevation also marks a transition from the dark, peaty soils of the mountains to the Piedmont's trademark red clay, which has oxidized just like the surface of Mars. Beneath the soil, the dense Precambrian granite of the Blue Ridge Mountains is replaced by largely metamorphic rock beneath the Piedmont.

The eastern boundary of the Piedmont—the Fall Line—is a less visible transition in most places, but the geological and ecological changes that occur as you enter the Coastal Plain are just as significant. The Fall Line is where the tougher metamorphic rock of the Piedmont gives way to softer sedimentary rock along the coast and where red clay gives way to sandy, yellow sediments. Because of the sudden change in composition and elevation, the Fall Line is home to numerous waterfalls and fast-moving rivers—perfect conditions for gristmills.

Of course, as a physiographic region, the Piedmont isn't confined to the state of North Carolina; it skirts the eastern side of the Appalachian Mountains all the way from Alabama to New Jersey. If you follow the Fall Line on the eastern edge of the Piedmont all the way up the Atlantic seaboard, you'll find it intersects virtually every major city from Atlanta to Philadelphia. As Michael A. Godfrey points out, this is not a coincidence. "The colonists, after setting up seaports at the mouths of major rivers, sailed upstream as far as they could" until they reached the sudden change in elevation at the Fall Line, the eastern boundary of the Piedmont, where they "founded commercial centers at which to gather the surpluses of what was then known as the continent's interior."

The most common phrase associated with the Piedmont by far is "gently rolling hills," and for good reason. The word *piedmont* is French for "foothill," after all, and the American Piedmont Province was named after a similar region in Italy, *Piemonte*, at the base of the Alps.

While much lower in elevation than the Blue Ridge Mountains, at 300 to 1,500 feet the Piedmont is still a lofty plateau compared to the coast. And unlike the rugged mountains or the swamp-covered Coastal Plain, the gentle hills of the Piedmont were fairly easy to navigate on foot, horseback and buggy, which explains why the most important trading routes east of the Mississippi were located here, connecting the Deep South with the Northeast. The legacy of those trade routes—the I-85 corridor—is home

to all of North Carolina's major cities today (Charlotte, the Piedmont Triad and the Triangle).

However, the Piedmont's landscape wasn't always so gentle. When the ancient supercontinents of Gondwana and Laurentia collided over 450 million years ago, the Appalachian Mountains were created. But they rose three to four times higher than they do today, as high as the present-day Alps and Andes (fifteen to twenty thousand feet), and there was no piedmont or coastal plain between them and the sea.

North Carolina, as we know it today, is the geological descendant of this once mighty mountain range. As the eons passed, the westernmost mountains in this ancient, supersized version of the Appalachians eroded down to the Blue Ridge Mountains we know today. The eastern part of those Appalachian ancestors was made of softer rock and thus eroded down even further, giving us the gentle, rolling hills of the Piedmont today—with the exception of occasional *monadnocks*, outliers like Crowders Mountain, Pilot Mountain and Hanging Rock that survived eons of erosion and weathering thanks to their durable quartzite foundations. Finally, the Coastal Plain was formed by sediment carried down out of the mountains by rain, erosion and gravity.

But slow-churning geological processes aren't the forces that have shaped the Piedmont's environment as we know it today. The ecology of the region has been massively and irreversibly altered by human beings. Almost every acre has been logged, clearcut, converted to farmland, paved over or destroyed at some point in the last three hundred years—even the acres we now revere as wilderness and parkland. Stands of old-growth forest are incredibly rare, so none of the sites in this book are unspoiled Edens. Instead, most are in the midst of a process called secondary succession, where trees and other vascular plants slowly return to abandoned farmland in a series of waves (for an in-depth look at ecological succession, see chapter 5).

Piedmont forests have been destroyed for a variety of reasons: first to make room for colonial gristmills and then, after the Industrial Revolution, textile and furniture factories. And today, the Piedmont is one of the fastest-growing urban centers in the United States, home to over 5 million people (5,427,058 in 2011). According to *Forbes* magazine in 2014, Raleigh and Charlotte are two of the ten fastest-growing cities in the country.

Outdoor adventures are one of the region's most popular pastimes; the Charlotte Hiking Meetup alone has over 2,500 members, the Triangle Hiking and Outdoor Group has over 3,000 and the state chapter of the Sierra Club boasts over 17,000. According to the state tourism bureau, over 45 million people visit North Carolina every year (sixth in the United States),

particularly in the warmer months from April through October, spending over $19 billion in 2012. Of those visitors, approximately 13.8 percent participate in rural sightseeing, 8.3 percent in national or state parks, 6.1 percent in wildlife viewing and 4.4 percent in hiking/backpacking.

Those kinds of visitation numbers create challenges for state parks. "As law enforcement officers, we occasionally see people at their worst," says Jason Anthony, a ranger at Hanging Rock State Park. "But as park rangers, we more frequently interact with them at their best." A few hundred miles west, Great Smoky Mountains National Park is the most-visited park in the United States, but heavy use has its consequences, as the Smokies are also regularly cited as the country's most polluted national park.

State parks in the Piedmont aren't as popular as the Smokies but still face challenges from increased visitation, decreased funding and aging facilities as they attempt to balance preservation with public access. "Hanging Rock has been getting much more exposure in the media and online," Anthony says, "which is good but has dramatically increased our visitation, while our staffing levels have been cut back slightly and our hours of operation have increased."

And another factor may tip the scales away from preservation: as of May 2015, Governor Pat McCrory plans to take all North Carolina state parks out of the Department of Environment and Natural Resources and put them into the Department of Cultural Resources, which currently oversees the state's museums and historic sites. Not everyone agrees with the idea.

"The intent is to put all of the state's attractions together, but I don't know if I like the idea of referring to state parks as 'attractions,'" says Greg Schneider, superintendent of Morrow Mountain State Park, forty-five miles east of Charlotte. "Our main focus is preserving and protecting natural resources. I worry that we might go too far in the direction of revenue generation and lose sight of the reason these areas were preserved when James Morrow and our forefathers called this 'a special place' that needs to be protected *and* shared with public." A February 2015 article in Wilmington's *Star-News* noted that many park employees share Superintendent Schneider's concerns about "the potential loss of focus on environmental stewardship and education in favor of tourism promotion."

Whatever the future holds, this book attempts to illustrate just how valuable and diverse the Piedmont's natural treasures are today. Though they may pale in comparison to the pristine wilderness of four centuries ago, the wild spaces that are slowly returning to forests in the North Carolina Piedmont are still home to hundreds of thousands of animals, enough plant species to fill an arboretum and sheer beauty.

Chapter 2
FLORA

This is what I see in the Piedmont of 300 years ago: the canopy claims the direct sunlight completely by filling every gap with a broad-leafed parasol, cantilevered aloft. No part of the jade awning is within one hundred feet off the ground. The trees holding it aloft are chestnuts, white oaks, mockernut hickories and tulip trees, immense and widely spaced. Only around the younger dominants, say those under 200 years old, could two lovers link hands.
—*Michael A. Godfrey,* A Sierra Club Naturalist's Guide: The Piedmont

The fairy-tale forests that blanketed the Piedmont three hundred years ago were all destroyed by European settlers. Today, nearly every acre is either farmland, abandoned farmland or paved over. This book is particularly focused on that abandoned farmland, which composes around 60 percent of the Piedmont today, according to Godfrey. As detailed in chapter 5, secondary succession is the predictable four-step sequence that nature takes when reclaiming farmland (or any other site severely damaged by man or natural disaster).

And so today, instead of towering, spacious "cathedral" forests, wild spaces in the Piedmont are in various stages of recovery, from grassy, herbaceous growth to young, coniferous forests and, finally, mature, mixed hardwoods with an oak-hickory canopy and an understory of heath, holly, dogwood and sourwood. An inexact but useful rule of thumb: when you encounter maturing pines or redcedars in the Piedmont, you're looking at a forest that's only been recovering for fifty to one hundred years.

While well-drained, mesic soils compose the majority of the Piedmont, the state parks and natural areas in this book are typically located at the site of a monadnock (with dryer, xeric soil) or a river (surrounded by wet, hydric floodplains). As a result, the ecosystems in protected natural areas are not necessarily representative of the Piedmont as a whole, since the uniqueness of these sites is part of the reason they were deemed special and worthy of preservation. The high monadnocks (Pilot Mountain, Hanging Rock, Crowders Mountain, Morrow Mountain, etc.) feature flora and fauna very similar to the Blue Ridge Mountains, for example.

Here are the most common vascular plants you'll encounter at the sites in this book (a site-specific listing of flora and fauna can be found at the end of each chapter).

EASTERN REDCEDAR (*juniperus virginiana*) is one of the earliest pioneer trees to return to abandoned farmland, not just in the Piedmont but across the eastern United States—sometimes in a mere six years after the land has been left to grow wild. Technically it's a juniper, not a cedar, and it grows in thin columns for up to eight hundred years. Its scaly evergreen leaves look like tiny artichokes, and its fragrant red bark is often sold as cedar blocks to keep drawers of clothes fresh. Always keep an eye out for cedar waxwings around redcedars; they love to eat its berry-like cones, which have been used to flavor gin since the seventeenth century.

VIRGINIA PINE (*pinus virginiana*) is the most common coniferous tree in the western third of the Piedmont. When you encounter it (or the other pines below), you're in a relatively young forest during its first century of secondary succession. Virginia pine only lives ninety to one hundred years, thanks in part to disease and infestations of southern pine beetles, so the vast majority will die before a forest reaches maturity and the canopy is dominated by hardwoods. Virginia pine needles are short and grouped in pairs with smallish cones and can be found through the Appalachian region from northern Alabama to southern New York, where it's listed as an endangered species.

SHORTLEAF PINE (*pinus echinata*) is the dominant conifer in the central third of the Piedmont. Taller and narrower than Virginia pine, its needles are actually twice as long (despite the name of the tree). It's an important source of timber in the southeastern United States and has the largest range of any southern "yellow pine," extending westward beyond the Mississippi and into Texas and Oklahoma.

Loblolly pine (*pinus taeda*) is the second most common tree in the entire United States (behind red maple) and the most common conifer in the eastern third of the Piedmont. Like the shortleaf species, loblolly is a southern "yellow pine" and an extremely valuable source of timber. It's the tallest of the three dominant Piedmont pines, with high branches on the top third of its trunk and long needles bunched in groups of three. In April, male cones release clouds of yellow pollen that blanket trails, cars and sidewalks across the eastern half of North Carolina.

Sweet gum (*liquidambar styraciflua*) is one of the earliest hardwoods to appear during secondary succession once the pioneer pines above have started to mature. Named for its sweet, resinous sap, sweet gum is also known for the pleasant fragrance of its star-shaped leaves when crushed, as well as its spiky, ball-shaped fruit capsules. Its timber is a key component in some plywoods, and its leaves turn bright red in autumn.

Red maple (*acer rubrum*) is another pioneer hardwood in the sub-canopy of most Piedmont forests, as well as the single most abundant tree in the United States, thanks to its ability to grow just about anywhere. Its three-lobed leaves are perhaps the best known in North America thanks to the Canadian flag and their brilliant crimson colors in autumn. Its sap is the source of maple syrup, and its wing-shaped fruits—samaras—are nicknamed "helicopters" and "whirligigs" for their slow, spiraling descent.

Flowering dogwood (*cornus florida*) is a bit of a trickster. Its beloved, massive white flowers in early spring aren't actually flowers at all but, rather, four white leaves called "bracts" encircling tiny clusters of bright green flowers that most people mistake as stamens or carpels. Dogwoods are small sub-canopy trees with bright red fruits in late summer that look like tiny tomatillos and leaves that turn blood-red in the fall.

Tulip tree (*liriodendron tulipifera*) is a shade-intolerant tree named for its cup-like flowers and also known as **yellow poplar**, even though it belongs to the magnolia family (in all fairness, its leaves do resemble those of poplar trees). In the Piedmont, it is a fairly common pioneer hardwood but tends to thin out after the first 150 years of succession. Native Americans throughout the Appalachians—including the Cherokee—used tulip tree trunks for their canoes.

Persimmon (*diospyros virginiana*) is a sub-canopy tree famous for its oval-shaped fruit, found in desserts, teas and even a few beers. A staple of hardwood forests south of the Mason-Dixon line, persimmon seeds were used as buttons on the uniforms of Confederate soldiers during the Civil War, according to the *Atlantic Monthly*. Its tear-shaped leaves turn gold in the fall.

Sassafras (*sassafras albidum*) can be difficult to identify since its unusually shaped leaves vary from one-lobed to two-lobed and three-lobed on any given tree, but the tri-lobed variety are impossible to miss. Known for its pleasing smell, sassafras usually begins growing underneath dominant hardwoods once they start reaching maturity. Its leaves turn yellow with fringes of red in autumn. The Cherokee never used sassafras branches to build fires since they were known to jump around like popcorn when heated.

Sourwood or **Sorrel tree** (*oxydendrum arboretum*) is known in the Southeast for the delicious honey and jelly made from its nectar and fruit, respectively, as well as its dark red to purple leaves in the fall. Typically a smaller understory tree, its dangling threads—called racemes—of white flowers are a hallmark of mid-summer throughout the southern Appalachians and Piedmont. Cherokee hunters used sourwood rods to skewer meat over a fire because of the wood's acidic flavor.

Chestnut oak (*quercus prinus*) is a dominant canopy tree in many of the Piedmont's mixed hardwood and monadnock forests but is also widespread throughout the Appalachians. Its ridged and fissured bark is easy to recognize, as are its long, broad leaves with shallow lobes that turn bright red in autumn. It has a tendency to grow multiple trunks, and its sweet acorns— some of the largest in North America—are a vital source of protein, fat and carbohydrates for wildlife, particularly white-tailed deer, wild turkeys and rodents. Chestnut oaks can grow in relatively dry, rocky environments, so you'll often see them on monadnock ridgetops and south-facing slopes, but they reach their greatest heights in low-lying floodplains.

Bear oak (*quercus ilicifolia*) is a smaller, shrub-like tree that needs lots of direct sunlight to survive. Thanks to a thick underground taproot, bear oak has near-supernatural abilities to withstand wildfires, severe storms and other harsh weather, even if all of the aboveground part of the tree is completely destroyed. This toughness makes it a perfect tree for exposed monadnock summits where it doesn't have to compete for sunlight. Its acorns are a favorite among black bears stocking up before hibernation, hence the name. Primarily a northeastern tree, North Carolina is the southern extremity of its range; it is a State Endangered Plant and can only be found atop a handful of monadnocks (Crowders Mountain, Hanging Rock, Pilot Mountain and the South Mountains).

White oak (*quercus alba*) is one of the most common hardwoods east of the Mississippi and was thus voted the state tree of Illinois, Maryland and Connecticut. Iconic, massive, broad and very long-lived, its deep-lobed leaves turn bright red in the fall. Despite its name, the bark of a white oak

is actually gray. Its acorns are smaller and less sweet than chestnut and bear oak but much more palatable than scarlet oak. Wine and bourbon whiskey are typically aged in barrels made of white oak.

AMERICAN CHESTNUT (*castanea dentate*) used to be ubiquitous in the northeastern United States. One out of every four trees in the Appalachian region was an American chestnut before 1900, according to estimates. But the chestnut blight fungus, accidentally introduced to North America around the turn of the century, destroyed almost all of them in the first half of the twentieth century. Today, smaller offshoots of those once mighty trees can be found in the understory of a few Piedmont forests, but not for long. Before reaching maturity, they, too, are killed by the blight. Its leaves are long and saw-toothed, turning gold in autumn.

MOCKERNUT HICKORY or **WHITE HICKORY** (*carya tomentosa*) is the most common hickory in mature Piedmont forests because it can grow just about anywhere with fairly mesic soil. Its eponymous nuts are popular with squirrels, white-tailed deer and black bears, but their giant, thick shells only contain a tiny amount of meat, "mocking" the wildlife that spend the time and energy to crack them.

SHAGBARK HICKORY (*carya ovata*) is easy to recognize once it reaches maturity thanks to its weird bark, which always looks like it's peeling off the trunk in stiff planks. Another common canopy tree among mature hardwood forests, shagbark hickory grows best on moister, northern slopes, turning bright, brilliant gold in autumn.

The peeling planks of shagbark hickory.

RIVER BIRCH (*betula nigra*) can be found in almost every floodplain in this book. Its papery bark appears to be peeling off the trunk in flakes (as opposed to the stiffer planks of shagbark hickory), and it is considered a "semi-aquatic" species by some botanists. It's the only birch in the Southeast that grows at low altitude, and its leaves turn yellow each autumn.

MOUNTAIN LAUREL (*kalmia latifolia*) is a common heath species throughout the Appalachian region but also thrives on Piedmont mondanocks and north-facing slopes. Like rhododendron, it's an evergreen shrub that grows in low-lying thickets, often blanketing the understory of oak-heath forests. Its branches are thin and twisting, and its leaves are large, glossy and dark-green. In the spring, mountain laurel is unmistakable thanks to its small, bright, iconic, cup-like white and pink flowers.

CATAWBA RHODODENDRON (*rhododendron catawbiense*) is another evergreen shrub with similar characteristics to mountain laurel, distinguished by its large clusters of purple, pink or red flowers, as well as longer leaves. The Catawba species has a fairly narrow natural range, mostly confined to the Appalachians of the Carolinas and Virginia but also some slopes in the Piedmont. It takes its name from the Catawba River near Charlotte. Cherokee Indians never used rhododendron or laurel in their fires; the hissing noise of its branches when heated reminded them of winter winds, and according to folklore, burning it would bring about cold weather (the prohibition was probably related to the plant's toxicity).

A blooming thicket of Catawba rhododendron.

Mapleleaf viburnum (*viburnum acerifolium*) is a deciduous shrub with broad three- to five-lobed leaves found in the understory of fairly mature hardwood forests beneath towering oaks. Plants with three-lobed leaves are easily confused with young red maples, except in the spring, when their purple drupes and white cymes make them easier to distinguish.

Bloodroot (*sanguinaria canadensis*) is one of the first perennial flowers to bloom in the spring. Almost resembling a tiny white water lily, its roots contain a highly toxic rhizome. Among Native Americans, including the Cherokee, bloodroot was a medicinal cure-all used to treat everything from heart and respiratory problems to nausea and unrequited love.

Bloodroot flowers.

May apple (*podophyllum peltatum*) is another perennial that thrives in moist soils and bursts up from the leaf litter in early spring, resembling waxy green umbrellas. Like bloodroot, its roots are toxic and its rhizome was used by Native Americans as a topical agent.

Jack-in-the-pulpit (*arisaema triphyllum*) is a unique herbaceous plant with an iconic hood that slowly unfurls throughout the spring. The sometimes-striped spathe "hood" is the eponymous pulpit, which attracts pollinators to the dark spadix within. Its clusters of three leaves are easily mistaken for poison ivy, and it prefers relatively moist soil beneath a mature oak-hickory forest.

Chapter 3

FAUNA

After we had supp'd and all lay down to sleep, there came a Wolf close to the Fire-side, where we lay. My Spaniel soon discovered him at which one of our Company fir'd a Gun at the Beast; but, I believe, there was a Mistake in the loading of it, for it did him no Harm. When they hunt in the Night, that there is a great many together, they make the most hideous and frightful Noise, that ever was heard.
—*John Lawson,* A New Voyage to Carolina

When John Lawson explored the Carolina Piedmont in 1701, he encountered elk, buffalo, wolves and mountain lions. Today, those species have all disappeared from the region, but plenty of majestic animals remain. "One day while cleaning campsites, I heard some kind of commotion on the river," says Jeff Davidson, superintendent of Raven Rock State Park. "I walked down and watched a bald eagle and an osprey fight over a largemouth bass. When one grabbed the fish off the river surface, the other would swoop in and knock it back into the water. The eagle finally took off with the fish, disappearing upstream with the osprey hot on its trail."

Bald eagles and ospreys aren't exactly bursting from state park boundaries in North Carolina, but they can certainly be found in the Piedmont if you know where and how to look. For a site-specific listing of flora and fauna (including bald eagles and ospreys), see the end of each individual chapter.

Here's a brief look at the most common animals in the North Carolina Piedmont's wilder spaces, though it's worth keeping in mind that many of the sites in this book have more in common, ecologically, with the Blue Ridge Mountains than the rest of the Piedmont.

A northern cardinal and an eastern gray squirrel.

WHITE-TAILED DEER (*odocoileus virginianus*) used to be common throughout North America but have been supplanted by mule deer west of the Continental Divide. In North Carolina—as in the rest of the eastern United States—they remain ubiquitous. In fact, without any natural predators (wolves, cougars and, believe it or not, alligators) left in North Carolina, some sites like the Pee Dee National Wildlife Refuge (see chapter 20) have instituted controversial "culling" programs to keep the deer population under control.

"We had a group of twelve deer who were so acclimated to humans, they would walk right up to visitors," says Greg Schneider, superintendent of Morrow Mountain State Park, which outsources some of its white-tailed deer to the Cherokee Indian reservation. "Deer can be aggressive. In bad winters, I've seen them fight over banana peels," he says. "We had one doe…somebody must have been feeding her out of a potato chip bag, and she had her head stuck in the bag, running around the park. We made a couple attempts to catch her, but she kept getting away. She eventually punched her head through the bag, so she wasn't blind anymore, but she

had the bag around her neck like a collar until we got her close enough with a cookie that we were able to free her."

According to Cherokee legend, white-tailed deer won its antlers by beating the rabbit in a footrace. Cherokee hunters would ask pardon before taking the life of a white-tailed deer and remove its back hamstrings before preparing the meat for fear that eating them would curse the hunter with poor running stamina.

North American beaver (*castor canadensis*) is the second-largest rodent in the world and can be found at virtually every lotic (flowing rivers) and lentic (still lakes and ponds) site in this book. That doesn't mean you're likely to see one, however, as they're primarily nocturnal. Keep your eyes peeled for their branch and mud lodges—which are much larger than you might imagine—along the banks of rivers and lakes. In the fall and winter, you may also see their semi-permanent dams, which they build to create reservoirs of deep water around their lodges that won't freeze during the winter. These dams actually create hydric micro-ecosystems called semi-permanent impoundments (see chapter 7). Thanks to its iconic incisors, the beaver was the Cherokee tooth fairy, thanked whenever a child's permanent teeth came in.

Raccoon (*procyon lotor*) is common in suburban and even urban areas, thanks to its learned dependency on human food. Nocturnal and highly intelligent, you may see them "washing" food by rubbing it in their hands if they find it in or near a body of water, leading to the *lotor* part of their scientific name, which is Latin for "washing." If you do encounter a raccoon in the wild (probably around dusk or dawn), be sure to give it a wide berth as you would any other form of wildlife. Despite their undeniable cuteness, raccoons are disease vectors for the deadly rabies virus, and infected animals can be very aggressive. Just ask Bob Davies, a park ranger at William B. Umstead State Park (see chapter 15) near Raleigh: "I was attacked by a rabid raccoon once in the park. It grabbed my leg, and I had to kick-throw it off." In Native American folklore, the raccoon was often regarded as a trickster figure along with coyotes and wolves, though not in Cherokee mythology.

Coyote (*canis latrans*) is usually associated with the Southwest in the American imagination but is actually widespread throughout North America, even in large cities like Chicago and New York. The coyote is more of a loner than its big brother, the gray wolf. Nuclear families only stay together for a year or so, parting ways after the pups have reached physical maturity. Unrelated adults will occasionally hunt together, however, when the prey is large enough. The coyote is almost exclusively carnivorous—eating

everything including mammals, birds, reptiles, amphibians and insects—but also snacks on tree fruit for extra carbohydrates and sugar. In most Native American mythologies, the coyote was a trickster figure like Thor's brother, Loki, a shapeshifting Norse deity.

"On my first day at work here, the former superintendent took me up into the backcountry on an ATV," says Keith Nealson, superintendent of Eno River State Park. "We drove over an old culvert on a dilapidated access road, and two coyote pups ran out of the culvert and bolted into the woods. I had seen coyote before but never pups. The former superintendent and I ecologically geeked out over it completely."

BLACK BEAR (*ursus americanus*) may be the mascot of western North Carolina's Great Smoky Mountains National Park, but a few still call the higher elevations of the Piedmont home, particularly monadnocks like Hanging Rock, South Mountains and Morrow Mountain. Your odds of encountering one east of the Blue Ridge Escarpment, however, are pretty low unless you're a careless camper. But if you know what to look for, you might see bear signs; like dogs, black bears mark their territory. They rub and claw at the bark of trees, so look for Wolverine-style claw marks a little below eye level on some of the thicker oaks and hickories. The Cherokee believed bears to be an ancient tribe of humans covered with hair whose town houses were perched on the high peaks of the Great Smoky Mountains.

VIRGINIA OPOSSUM (*didelphis virginiana*) is probably best known for being ugly, which hardly seems fair, but also for playing dead when threatened by a perceived predator (thus the expression "playing possum"). Seeing one in the wild is relatively rare since they're nocturnal like many of the Piedmont's mammals, but you'll probably pass a few lying dead on the side of the road in the more rural parts of the region. Like raccoons, they seek out human food in garbage cans, but their favorite woodland meal is the fruit of persimmon trees. In Brasstown, North Carolina, deep in the Blue Ridge Mountains, the annual Possum Drop—where a live possum is lowered in place of a ball on New Year's Eve—has received national media coverage, including in the *New York Times*, as well as scrutiny from animal rights organizations. According to Cherokee folklore, the opossum once had a beautiful tail until the other animals grew so tired of him bragging about it that they asked a cricket to cut all the hair off, leaving behind the thin, fleshy tail we see today.

NORTHERN CARDINAL (*cardinalis cardinalis*) is easily recognizable as the state bird but perhaps a bit underappreciated for its beauty because of its ubiquity throughout North Carolina. The bright red plumage of the males lead to the species' name, after the red robes of Roman Catholic cardinals. Females are

A male northern cardinal calls for his mate.

more of a faded gold with muted patches of red on the wings, tail and crest. Males are very territorial, staking out their grounds with song and defending it aggressively against other males. In spring, males are often seen together with females, and the males will bring the females seeds and berries to eat during courtship. In Cherokee mythology, the cardinal—or "redbird"—was the daughter of the sun, killed by the rattlesnake and later resurrected from the land of the dead by the Cherokee.

RED-TAILED HAWK (*buteo jamaicensis*) is perhaps the most visible raptor in the Piedmont, if only because of its size when compared to the also common but smaller broad-winged hawk, red-shouldered hawk, Cooper's hawk and others. At a distance, it can be difficult to distinguish from the other hawks mentioned above, but look for the characteristically red tail feathers. As a bird of prey, red-tailed hawks are carnivores and can often be seen ripping into a ground squirrel or scanning open areas from the edge of an adjacent forest. Like the velociraptors in *Jurassic Park*, red-tailed hawks will sometimes hunt in pairs: one bird will flush the prey into the waiting jaws of the other. "Clever girl," indeed.

Copperhead (*agkistrodon contortrix*) is one of only two venomous snakes found in the Piedmont, along with the timber rattlesnake. It likes to perch on rocky outcrops in mixed hardwood forests, sitting perfectly still and waiting for something tasty to walk by, usually a small rodent. Copperheads are relatively shy and will typically slither away from humans unless they're surprised and threatened. Their venom is the least potent of all pit vipers, but their extremely painful bites are still serious enough to require immediate medical attention to avoid bone and muscle damage. For some reason, the Cherokee revered rattlesnakes but hated copperheads, believing them to be descendants of a giant evil serpent.

PART II

State Parks

Chapter 4
GUARDIANS OF STONE

CROWDERS MOUNTAIN

The temple interior, the belly of the whale, and the heavenly land above, beyond, and below the confines of the world, are one in the same. That is why the approaches of and the entrances to temples are flanked and defended by colossal gargoyles: dragons, lions, devil-slayers with drawn swords, resentful dwarves, winged bulls. These are the threshold guardians to ward away all incapable of encountering the higher silence within.
—*Joseph Campbell,* The Hero with a Thousand Faces

Thirty miles west of Charlotte, two mountains loom over Interstate 85 like great waves on a green sea. To borrow a term from the mythographer Joseph Campbell, they are "threshold guardians" of a liminal space between two worlds. Before the arrival of Scotch-Irish settlers in the eighteenth century, these mountains were boundary markers separating two warring Native American tribes: the Cherokee to the west and the Catawba to the east. Today, they mark a different kind of boundary: an ecological and geological transition from North Carolina's western mountains to its central rolling hills.

The two peaks of Crowders Mountain State Park aren't part of the Blue Ridge Mountains, which lie another fifty miles east. They're actually the last remnants of another group of mountains—the ancient Kings Mountain Range, formed over 450 million years ago when Gondwana collided with Laurentia—eroded away by harsh weather and deep time. They are monadnocks, a Native American word borrowed by geologists to describe

lone mountains surrounded by flat plains. They survived erosion because they're made of something valuable, strange and blue. So valuable, in fact, the mountains were almost strip-mined in the 1970s. But I'm getting ahead of myself.

I spent most of my childhood here, in the shadow of these guardians. Their contours hovered over my youth in Shelby, North Carolina, like twin moons. The giant circus tent of Crowders Mountain, with its radio tower jutting from the summit, and Kings Pinnacle, slightly taller at 1,705 feet, which as a child looked exactly like a giant replica of my grandfather's Cadillac, petrified and choked with foliage. I felt lost for the very first time here, as a child beneath these mountains, running ahead of my father along the banks of Shorts Lake. I encountered my very first dragonfly, as magnificent and grotesque to me as a mythical creature from Middle-earth.

Two decades later, in the dog days of August, I bring my wife to Crowders Mountain State Park on the first of many field research trips for this book. By the time we reach the trailhead, it is over ninety degrees Fahrenheit, and we congratulate ourselves for leaving our dog at home in the air conditioning. As we climb the popular Pinnacle Trail from the visitor center to the summit of Kings Pinnacle, we move through the park's four distinct ecosystems, each higher and drier than the last.

At its lowest elevations (less than eight hundred feet), the park consists of small-stream alluvial forests: relatively flat floodplains laced with small rivers and creeks that flood during heavy rains, infusing the soil with rich nutrients. As a result, stream forests are home to a wide variety of plant and animal life. At Crowders Mountain State Park, you'll find stands of river birch and groves of red maple soaking up the moist, fertile soil. You'll pass the golden, six-pointed stars of yellow trout-lilies and the green, priestly hoods of jack-in-the-pulpit.

Next, on the lower slopes beneath 1,200 feet, you'll move into the park's largest ecosystem: a mixed hardwood forest, one of the most common forest types of the Piedmont. The soil here is well drained and slightly more acidic than down below. The dominant trees are oaks—particularly the chestnut oak, with its beveled bark and bright green acorns that look like white grapes—but you'll also find flowering dogwood, whose giant, white, bisexual flowers are a hallmark of April in North Carolina, and sourwood, producer of the best honey on earth. If you walk quietly enough, you may spot a gray fox or the speckled breast of an ovenbird.

It's here in the mixed hardwood forest where, on the northeastern slopes of Crowders Mountain, Dr. Francis M. Garrett built the All-Healing Mineral

Springs Health and Pleasure Resort in the late 1800s, a luxurious three-story hotel near a mineral spring. "Lung and Throat Diseases, Dyspepsia, Bleeding Piles, General Debility, and Skin Diseases cured by the use of these waters," boasts an advertisement on display at the park's present-day visitor center. In 1884, Dr. Garrett added a seminary for girls to the property that later became Linwood College, a school that trained poor young women to become schoolteachers before it ran out of money and closed in 1921. The site was completely abandoned and today lies in weed-choked ruins.

As my wife and I continue our sweltering ascent through the oaks, we reach the park's third ecosystem. The Piedmont monadnock forest is the high, rocky realm of fire-tolerant plants and acidic soil between 1,200 and 1,500 feet. Chestnut oak dominates again here, with less competition than down below in the mixed hardwoods. You may hear the song of pine warblers passing through, on the hunt for food to bring back to their nests at lower elevations.

The hiking trails at this level are strewn with boulders, some of them large enough to house a family of trolls. "They seem to be one of three things," says Dr. Missy Eppes, professor of earth sciences at the University of North Carolina–Charlotte. Eppes and her students have been studying the boulder fields along the trail to Kings Pinnacle to determine their age. "In some cases, it's just gravity-driven debris coming down off an outcrop and spreading out on the slopes below. Sometimes they're linear features

A large boulder field on the Pinnacle Trail.

left over from some catastrophic landslide. And then you see boulders that are part of the outcrops themselves, where the outcrop is weathering in situ, leaving behind these boulders."

As my wife and I climb higher and suck down water to fight off heat exhaustion, the tree canopy above us opens up and the sun pours through. We've reached the fourth and final environment at 1,500 feet, the low-elevation rocky summit, found in only a handful of places in the Piedmont, and the best place to see how these mountains were made and why they were almost destroyed forty years ago.

The summit of Kings Pinnacle (see color insert, figure 1) is an ecological island in the sky, an isolated landscape of rocky outcrops exposed to the sun, strong winds and summer storms. The only soil to be found is clumped in pockets and crevices in the rock, where Catawba rhododendron thickets bloom pink and purple in the spring. Clusters of tiny white flowers burst from tall stalks of bear grass like upside-down chandeliers. And the southernmost instance of bear oak—a State Endangered Plant that grows in only four known places in North Carolina—thrives here thanks to the open canopy. These bear oaks only grow nine to ten feet tall; like bear grass (also known as turkeybeard), they rely on fires to clear the canopy of taller competitors for precious sunlight.

Dwarf versions of Virginia pine grow here, too, only reaching three to six feet in height. Like bonsai, their growth is stunted by their environment—in this case, the mountain's exposed cliffs, where taller trees are knocked down by storms and strong winds (see color insert, figure 3). "Their stiff, crooked roots grip the storm-beaten ledges like eagles' claws, while their lithe, cord-like branches bend round compliantly, offering but slight holds for winds, however violent," said John Muir, describing similar dwarf pines atop the mountains of California.

But it's here at the summit that Kings Pinnacle reveals the mystery of Crowders Mountain State Park—the reason why these twin peaks have survived for hundreds of millions of years, and the reason they were almost destroyed.

It's the rocks. When those prehistoric supercontinents collided to form this range, the intense pressure produced a metamorphic substance called kyanite quartzite, a mix of two minerals that are renowned for their toughness and erosion resistance. Standing among the sheer cliffs atop Kings Pinnacle, you can clearly see that the rock formations are clumped together in vertical layers, like books on a shelf, thanks to the violent horizontal forces that created them all those years ago (see color insert,

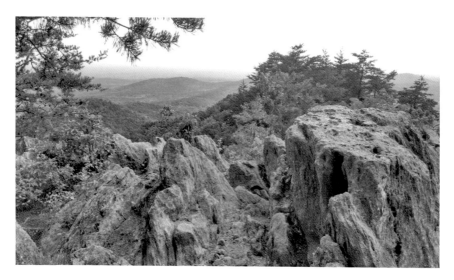

The rocky summit of Kings Pinnacle.

figure 2). While the rest of the Kings Mountain Range—composed of a softer mineral called schist—was weathered down to nothing, Crowders Mountain and Kings Pinnacle still tower over Gaston County because of these stoic stones.

Quartz, you're familiar with from museum gift shops and Superman's Fortress of Solitude. It's the milky white crystalline mineral that nature uses as a base to make gemstones like amethyst and onyx. Kyanite, however, is blue and a valuable resource for manufacturers of ceramics, spark plugs, dishware and porcelain pipes. Miners call kyanite crystals "blue daggers," and if it wasn't for the Gaston County Conservation Society, a mining company would have destroyed both Crowders Mountain and Kings Pinnacle in 1970 to dig them up.

If that sounds like hyperbole, look no farther than five miles south, where a massive gash in the earth marks the site of Henry's Knob. Once a kyanite-quartzite monadnock itself, today the abandoned open-pit mine is a bare, unsightly wound under investigation by the Environmental Protection Agency for chemical contamination of the surrounding groundwater and soil.

To save Crowders Mountain from strip-mining in the 1970s, Gaston County residents formed a conservation campaign. "The fight to save the mountain began when a young man discovered surveyors on the mountain and a plan to strip-mine for kyanite," says Fred Moss, a member of the Gaston

Conservation Society. "His father called a meeting at the courthouse…and the fight was on." Word spread at Gaston College, UNC-Charlotte and the North Carolina Chapter of the Sierra Club, and a march was held to protest the strip-mining plan on October 30, 1971.

Bob Bigger, a sixty-three-year-old journalist in Gastonia, was one of the members of the Gaston College Ecology Club who planned and participated in the march. "The Sunday before the march, Ralph—the leader of the Ecology Club—got an ominous visit from a man in a pickup truck. The man had a pistol and warned him that if the fuss over the mountain continued, they'd find Ralph dead on it." The Ecology Club went ahead with the march regardless. "I think my life has been spent trying to recapture the happiness, the sense of purpose and mission of that experience," Bob says.

Thanks to the advocacy of local citizens, Crowders Mountain and Kings Pinnacle were saved, and Crowders Mountain State Park opened shortly thereafter in 1974. For the record, it wasn't named after local farmer Ulrick Crowder but after nearby Crowders Creek, whose namesake is lost to history. Its trails are a popular weekend getaway for citizens of nearby Charlotte, and its 150-foot cliffs are beloved by rock climbers and boulderers. "Even after a visit to the spectacular Yosemite, my enjoyment of Crowders is in no way diminished," says Steve Copulsky, chair of the Sierra Club's North Carolina Chapter.

When my wife and I reach the summit, we find a quiet spot on the cliffs to eat lunch. Despite the heat, the air is relatively clear. On one side of the mountain, I can look down and see Shelby, the small town where I grew up. On the other, in the distant haze, I can see the skyline of Charlotte, the city where we live now. As with the Cherokee and the Catawba, these mountain guardians still stand at the threshold between two worlds. Out of breath, I turn to my wife and almost ask her if she thinks the climb was worth it. When I see the look on her face as she gazes out over the sea of trees beneath us, I don't have to ask.

———◆———

TREES AND SHRUBS: bear oak, chestnut oak, American chestnut, red maple, Catawba rhododendron, ground juniper, American holly, dwarf juniper, eastern redcedar, flowering dogwood, mountain laurel, persimmon, sourwood, pink azalea, eastern redbud, honey locust, black locust, American beech, white oak, scarlet oak, black oak, American witch hazel, sweet gum, pignut hickory, white hickory, sassafras, eastern white pine, loblolly pine, shortleaf pine, Virginia pine

SMALLER PLANTS: Bradley's spleenwort fern, Biltmore's carrionflower, jack-in-the-pulpit, periwinkle, New England aster, white heath aster, fleabane, goldenrod, cardinal flower, galax, Christmas fern, Japanese honeysuckle, elderberry, dwarf iris, St. John's wort, Carolina lily, beargrass, cinnamon fern, wood anemone, Carolina rose.

FUNGI: velvet-top fungus, dog stinkhorn, American Caesar's mushroom, turkey tail, crowded parchment, false turkey tail, oak-loving collybia

MAMMALS: muskrat, raccoon, eastern cottontail, eastern chipmunk, coyote, beaver, bobcat, northern river otter, white-tailed deer, southern flying squirrel

REPTILES AND AMPHIBIANS: Carolina pygmy rattlesnake, pickerel frog, northern cricket frog, dusky salamanders, two lined salamanders, eastern cricket frog, green tree frog

BIRDS: wood duck, mallard, hooded merganser, northern bobwhite, wild turkey, double-crested cormorant, great blue heron, green heron, yellow-crowned night-heron, black culture, turkey vulture, cooper's hawk, red-shouldered hawk, red-tailed hawk, eastern screech-owl, great horned owl, ruby-throated hummingbird, white-eyed vireo, Carolina chickadee, tufted titmouse, eastern bluebird, pine warbler, yellow-rumped warbler, field sparrow, song sparrow, dark-eyed junco, scarlet tanager, northern cardinal, indigo bunting, red-winged blackbird, eastern meadowlark, brown-headed cowbird, purple finch, house finch

Chapter 5
THE FLOWER OF CAROLINA

ENO RIVER

*Natural places are no different than human cities. The old exists next to the new.
Invasive species integrate with or push out native species. The landscape you see
around you is the same as seeing an old cathedral next to a skyscraper.*
—*Jeff VanderMeer*, Acceptance

In 1700, the interior of North Carolina was still largely unexplored by
Europeans when John Lawson, an adventurous English naturalist, set
out from Charleston with a group of fellow explorers, tasked by the Lords
Proprietors with surveying the Carolina frontier. A few years later, Indians
would torture Lawson by sewing dozens of pine splinters into his skin before
burning him alive at the start of the Tuscarora War.

But before that, in February 1701, Lawson's expedition stumbled upon
another group of Europeans near present-day Hillsborough who advised
them to seek out an Indian named Enoe Will, ruler of a stream-laced
kingdom of exquisite beauty nearby. "[T]hey had never seen 20 Miles of
such extraordinary rich Land, lying all together, like that betwixt Hau-River
and the Achonechy Town," Lawson wrote in *A New Voyage to Carolina.*

This twenty-mile stretch of land, which Lawson would go on to call the
"Flower of Carolina" for its unmatched beauty, is the site of Eno River
State Park. The park and the river were named for the Eno tribe of Native
Americans, of which Enoe Will was chief. Seen from above, the Eno River
is a thin blue vein that snakes from northern Orange County down to
Hillsborough and then east through the park before flowing into Falls Lake

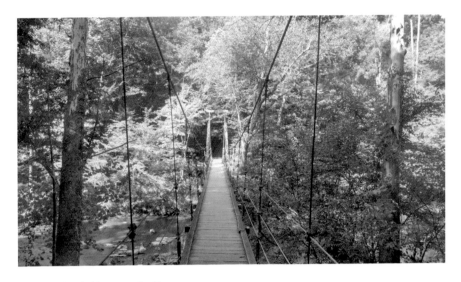

A suspension bridge over the Eno.

(see chapter 16) on the far side of Durham. Altogether, the river runs about forty miles.

Compared to the major rivers of North Carolina—the Neuse, the Yadkin or the Cape Fear—the Eno seems small and inconsequential. But the beauty and diversity of life found here has been attracting and inspiring people for thousands of years—from the Eno tribe to the very first European settlers who founded Durham and Chapel Hill—while the river's unique geology drew over thirty gristmills to the area, the ruins of which still haunt the park to this day.

The park straddles both sides of the river along two sharp bends, forming a rough Z shape a few miles north of I-85. Most of the park is composed of bottomland hardwood forest in the low-lying floodplain of the Eno, home to river birch, witch hazel, sycamore, American hornbeam and beavers working on their homes at night. But the Eno is an "incised river" that has slowly carved its way deeper and deeper into the earth, creating narrow ravines (see color insert, figure 5). As a result, some of the higher slopes above the river are more mesic. Upland species like oak and hickory grow here, along with mountain laurel and rhododendron.

"I feel like each visit can bring a new experience," says Liz Stabenow, education director at the Eno River Association. "The Eno is blessed with a bounty of varying landscapes. One day I might climb a mountain, the next visit a prairie, the next float in the water and play in the cascades. The

abundance of spring wildflowers, the clean water and the fish swimming along in it and the birds flying overhead make me feel like there is always a new story to tell."

When I visit Eno River River State Park on a humid day in mid-August, it's rife with mushrooms as plentiful and colorful as Lewis Carroll described in *Alice's Adventures in Wonderland* thanks to a recent rainstorm. Golden clumps of honey mushrooms cling to the feet of hardwoods, while deadly white chlorine amanitas—named for their distinct swimming-pool smell—burst from open patches of leaf litter, big as dinner plates. Wandering aimlessly through the forests in the Fews Ford area of the park, it's easy to feel like you've stepped back in time to an era before the arrival of European settlers.

But that feeling is an illusion. This landscape looks completely different today than it did a few centuries ago. Unfortunately, when those settlers started moving inland from the Coastal Plain to live along the banks of the Eno, they did what European settlers tend to do: they cut down trees for timber and cleared land for farming and grist milling.

"Anywhere you walk in the Piedmont, you see evidence of seventeenth- and eighteenth-century farming," says Dr. Missy Eppes, the professor of

Coker's amanita, a poisonous mushroom fond of oak and pine trees.

earth sciences at UNC-Charlotte whom I interviewed about her ten years of research in the region. According to Eppes, most of the steep ravines and high bluffs surrounding Piedmont rivers like the Eno simply did not exist before Europeans arrived three hundred years ago.

"The big, broad valley bottoms with thick floodplain deposits are probably almost exclusively a function of mill dam sedimentation. The valley bottoms were probably meandering streams and wetlands, with riverbanks only this high," Eppes says, her hand hovering a foot off the table of the faculty dining room at UNC-Charlotte, "instead of where they are today."

And indeed, a study by some of Eppes's colleagues at North Carolina State University found that

> *land clearing associated with agriculture and development increased upland erosion rates 50–400 times above long-term geological rates. Much of the eroded sediment was subsequently [raised] on floodplains and impounded behind milldams. This trapped "legacy" sediment, commonly mistaken for natural floodplain deposition, has gone largely unrecognized until recently.*

Translation: we created the steep valleys in Eno River State Park, not nature. Evidence of the thirty-something gristmills that once operated here is still visible, even from the park's trails. In addition to crumbling stone ruins, you'll pass several of the channels—or "races"—that once funneled water from the river to the mill and back.

An old millrace that carried water from a historic gristmill back down to the river.

I ask Eppes, point-blank, "Does it matter that Piedmont river valleys like the Eno are so much deeper today because of all these old mills?"

And then she gets serious for a moment. "The number one polluter of streams is sediment. Not chemicals. And the majority of that polluting sediment is coming from bank erosion of those legacy sediments from abandoned mills."

But it wasn't just mill sedimentation that drastically changed the landscape here. The forests at Eno River State Park are also in various stages of regrowth, a process ecologists call "secondary succession." As Eppes and her colleagues mentioned, most of the forests you can find in the Piedmont today aren't very old. After over three hundred years of human activity, the vast majority of North Carolina has been logged or cleared at some point. Remaining stands of old-growth forest are very few and far between.

It can take anywhere from 150 to 500 years for a hardwood forest to mature completely again, so in the meantime, ecological succession is the way nature slowly reclaims the land. There are four distinct, predictable stages in the secondary succession process, all of which are visible and ongoing at Eno River State Park.

First, an old-growth forest is destroyed by a natural or man-made disaster that removes most of the vegetation while leaving the soil relatively intact. Wildfires, storms, severe floods and droughts, as well as clearcutting for timber or farmland, can kill most or all of a forest's flora and fauna. At Eno River State Park, trees were removed to make room for farms and mills until the middle of the twentieth century, when the park was founded.

If left to nature's devices, "pioneer" species of plants will begin to colonize abandoned farmland in the first stage of succession. Herbaceous grasses like crabgrass, ragweed, horseweed and St. John's wort shoot up quickly to dominate old fields and bask in the unobstructed sunlight during the first year, followed by taller species like Queen Anne's lace, broomsedge and goldenrod. Take a quick glance at the Pleasant Green area of the park on Google Earth, and you'll see plenty of old fields that look empty but are actually progressing through this first stage.

Next, small, woody shrubs like blackberry and Japanese honeysuckle begin to sprout up among the pioneer grasses, as well as the very first trees. Edward Kuenzler, in his incredibly detailed analysis of succession in *Time and the Piedmont*, identifies loblolly pine as the most common. At Eno River State Park, the southernmost bend in the river features a large grassy area dotted with young pines on its northern banks.

As these fast-growing pines begin to dominate and form a canopy in fifty to one hundred years, succession enters its third phase: the softwood forest, where tall evergreens reach maturity while mixed hardwoods and new shade-tolerant ferns and vines start growing beneath them. Finally, the hardwoods take over after the pines start to thin out from death and disease. In the Piedmont and at Eno River, oak and hickory dominate, but red maple, sourwood, dogwood and persimmon are common, too.

"Most of the park has now left the stage of succession dominated by pine trees," says park superintendent Keith Nealson. "You can still find the foundations of old farms and mill structures, but even those are slowly being broken down and hidden away." Once a recovering forest reaches the mixed hardwood stage, it's considered a "climax community," marking the end of the process of succession.

At least, that's the way Henry Chandler Cowles, an ecologist at the University of Chicago, formulated the concept of succession after his work at the Indiana Dunes in the 1890s. However, while you'll still see the term "climax community" used in field guides, modern ecologists tend to think of succession as an ongoing, cyclical process with no predetermined endgame. Forests are constantly adapting to natural and unnatural factors that affect their growth and diversity, so it's misleading to think of mixed hardwoods as a final result. The notion of ecological maturity—or equilibrium—is relative, given enough time.

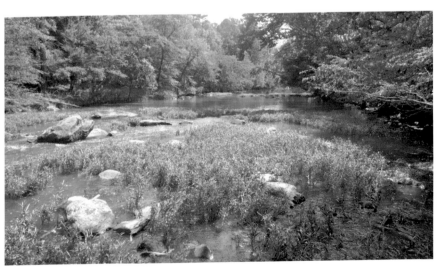

Standing in the middle of the Eno River.

"I'd love to see a prescribed burn program here, to restore a more natural order to certain areas of the park, but proximity to so many private homes makes it logistically difficult," says Superintendent Nealson. But once all of Eno River State Park has recovered from clearcutting and mature, mixed hardwood forests cover the banks of every bend and the slopes of every bluff, the ecosystem—if not the landscape—will be similar to what it was when John Lawson deemed it the "Flower of Carolina" in the early eighteenth century. "I just wish more people knew it existed," Nealson says. "So many local people don't even know it's here."

———◆———

TREES AND SHRUBS: pawpaw, American holly, black holly, brook-side alder, river birch, American hornbeam, American hazelnut, eastern hop-hornbeam, flowering dogwood, Chinafir, eastern redcedar, squaw, huckleberry, eastern redbud, bristly locust, American wisteria, laurel-leaf oak, willow oak, northern red oak, yellow corydalis, black walnut, crape myrtle, tulip tree, southern magnolia, black tupelo, white ash, American ash, green ash, shortleaf pine, long-leaf pine, eastern white pine, loblolly pine, Virginia pine, eastern hemlock, sycamore, broom-sedge, black cherry, common pear, sugar maple, box elder, red maple, painted buckeye, winged elm, scuppernong, Virginia creeper, American witch hazel, sweet gum, pignut hickory, white hickory, sassafras

SMALLER PLANTS: Bradley's spleenwort fern, Biltmore's carrionflower, jack-in-the-pulpit, periwinkle, New England aster, white heath aster, fleabane, goldenrod, cardinal flower, galax, Christmas fern, Japanese honeysuckle, elderberry, dwarf iris, St. John's wort, Carolina lily, beargrass, cinnamon fern, wood anemone, Carolina rose, green dragon, Jerusalem artichoke, trumpet-creeper, wild radish, Venus's looking-glass, eastern blue-eyed-grass, Solomon's-seal, Catesby's trillium, yellow trout-lily, eastern yellow stargrass, Indian-pipe, evening primrose, bloodroot, whorled loosestrife, black nightshade

FUNGI: black jelly roll, caterpillar fungus, chlorine amanita, Coker's amanita, dead man's fist, destroying angel, devil's urn, false turkey tail, hedgehog fungus, honey mushroom, jack-o'-lantern mushroom, jelly ear, lobster mushroom, luminescent panellus, oak-loving collybia, orange jelly cap, oyster mushroom, round-headed cordyceps, the deceiver, turkey tail, yellow cap

MAMMALS: muskrat, raccoon, eastern cottontail, eastern chipmunk, coyote, beaver, bobcat, northern river otter, white-tailed deer, southern flying squirrel, red fox, gray fox, American mink

REPTILES AND AMPHIBIANS: copperhead, yellow rat snake, corn snake, eastern snapping turtle, eastern box turtle, yellow-bellied slider, northern spring peeper, upland chorus frog, dusky salamander, two lined salamander, eastern cricket frog, green tree frog, Neuse River waterdog, pickerel frog, red-spotted newt

BIRDS: black vulture, pileated woodpecker, Kentucky warbler, hooded warbler, scarlet tanager, wood duck, mallard, bufflehead, common loon, white ibis, Mississippi kite, American kestrel, merlin, hooded merganser, northern bobwhite, wild turkey, double-crested cormorant, great blue heron, green heron, yellow-crowned night-heron, turkey vulture, cooper's hawk, red-shouldered hawk, red-tailed hawk, eastern screech-owl, great horned owl, ruby-throated hummingbird, white-eyed vireo, Carolina chickadee, tufted titmouse, eastern bluebird, pine warbler, yellow-rumped warbler, field sparrow, song sparrow, dark-eyed junco, northern cardinal, indigo bunting, red-winged blackbird, eastern meadowlark, brown-headed cowbird, purple finch, house finch

Chapter 6
MOUNTAINS AWAY FROM THE MOUNTAINS

HANGING ROCK

It is the wildest, most spectacular place in the Piedmont!
—*Michael A. Godfrey,* A Sierra Club Naturalist's Guide to the Piedmont

Far inward they glimpsed a tumbled mountain mass with one tall peak...there
stood like a sentinel a lonely height. About its feet there flowed, as a thread of
silver, the stream that issued from the dale; upon its brow they caught, still far
away, a glint in the rising sun, a glimmer of gold.
—*J.R.R. Tolkien,* The Two Towers

Approaching Hanging Rock State Park from the north, the broad, rocky plateau I see towering one thousand feet above the surrounding countryside looks remarkably like the mythical realm of Edoras, a lofty hill described above in Tolkien's *The Lord of the Rings* (see color insert, figure 7).

While there are no golden halls atop Hanging Rock, in autumn its bluffs are crowned with golden oak and hickory and its topography is remarkably similar, right down to the "thread of silver," a fast-flowing mountain stream called Cascades Creek that has carved narrow canyons into the rock.

I spoke with Jason Anthony, a park ranger at Hanging Rock for twelve years, about what sets this lofty plateau apart from other state parks in North Carolina. "While still technically in the Piedmont, the park has trails to rocky peaks and waterfalls unlike those found anywhere else in the region," Anthony says. "The spring wildflower and autumn foliage displays rival those of the mountains and are a much closer drive for people living in the state's major population centers."

And indeed, while Hanging Rock State Park is just a short thirty-minute drive north of Winston-Salem, the topography, flora and fauna have a lot more in common with the Blue Ridge Mountains much farther west than they do with the rest of the Piedmont.

Like the peaks in Crowders Mountain State Park (see chapter 4), the rocky bluffs at the top of the park—Hanging Rock, Moore's Knob, Devil's Chimney, Moore's Wall and Cook's Wall in particular, which range from 1,700 to 2,500 feet—are the quartzite remains of a lost, eroded mountain chain. In this case, it is the ancient Sauratown Mountain Range, which also left Pilot Mountain behind (see chapter 12). Their Native American namesake, the Saura tribe, is also lost to history.

Today, the high cliffs of Moore's Wall and Cook's Wall are perfect nesting sites for peregrine falcons, ravens and other birds. The exposed bluffs that provide hikers with unobstructed vistas are dotted with dwarf pines, oaks and hemlocks, including the largest population of bear oak in the state atop Moore's Wall, according to local biologist Marshall Ellis.

Bear oak was so named because of how popular its acorns are with bears just before hibernation. "We rarely see black bears," says Anthony, "but one night, a camper was eating in his tent, and a black bear walked up and let itself in. It and the terrified camper ended up just staring at each other before the bear turned away and went back into the woods."

Since bears are so rare at Hanging Rock, his superintendent offered a lobster dinner to any ranger who could get a good photo of the bear for their wildlife inventory. Anthony recalled, "I got a report from some picnickers that our nuisance bear, looking for food, had just chased them away from their table. I walked down, and sure enough, there was the bear, gorging on the remnants of some burger patties left on the grill. I had to try and get close to get a good shot, as it was beginning to get dark. I approached…and the bear saw me, turned and began to walk toward me. I took a quick picture or two and slowly walked backward until the bear lost interest. The pictures turned out blurry because my hands had been trembling when I took the shots. I didn't get the lobster dinner."

The park's namesake, Hanging Rock, is a leaning quartzite tower that appears to defy gravity. The view from its overhang is the best in the park, looking out over all that is left of the once-mighty Sauratown Range. In the right light, Hanging Rock and the other vertical drop-offs resemble the White Cliffs of Dover (although those English landmarks are composed of chalk, not quartzite).

Slightly lower elevations beneath the bluffs are more thickly wooded with hickory, red maple and especially multiple-trunked chestnut oak and are brimming with wildlife. "Most frequently we encounter whitetail deer, raccoons, opossums, gray squirrels, foxes, wild turkeys, black and turkey vultures, an assortment of hawks and owls and coyotes," Anthony says.

Coyotes? "We hear them yelping late at night. Kind of eerie at two o'clock in the morning, but you get used to it." Despite widespread associations as a western animal, coyotes spread to North Carolina in the 1980s and have been spotted in all one hundred counties of the state by the North Carolina Wildlife Resources Commission.

The steep river valleys carved by Cascades Creek are home to yet another kind of ecosystem, filled with rhododendron, mountain laurel, hemlock and stands of river birch, the sweet sap of which was turned into syrup by Native Americans. Thin gray birches perch atop the falls, far south of their usual range, and surrounding the cascades are spray cliff communities of mosses and liverworts (for a more detailed look at spray cliff communities, see chapter 14).

Of all the sites I visited to take photos and conduct field research for this book, Hanging Rock State Park may be the most beautiful. To reach the park's trail system, I take a winding road several hundred feet up the

An exposed vein of quartz.

Cascade Creek Falls from the overlook.

northern side of the plateau between Moore's Knob and the eponymous Hanging Rock. It's early November, and Anthony wasn't kidding about the fall foliage. Oaks and hickories shine gold in the late-afternoon light, along with blood-red and dark purple sourwood leaves (see color insert, figure 8). Beneath me on the trail, bright veins of quartzite bulge out of exposed stone, almost indistinguishable from snow at a distance.

After a short walk, the trail skirts one side of a narrow ravine. Above, the sun is just beginning to set behind the ghostly gray cliffs on the other side of the valley. Below, a fast-running stream is hidden by rhododendron and mountain laurel. Minutes later, I come to a wooden platform overlooking the twenty-five-foot Upper Cascade Falls, one of the park's five beautiful waterfalls, and find a boy no older than ten admiring the view.

For a moment, I'm alarmed. The boy turns to me. "You can go down there, you know," he says, pointing to the far side of the platform near the falls. "It's way cooler down there."

I approach the edge to find a partially hidden stairwell heading to the base of the falls (see color insert, figure 12)—and, much to my relief, the boy's father. When he joins his son and me on the platform, he tells me not to leave before climbing down to the base of the falls. "I already told him that, Dad," his son laments, and we part ways, leaving me thinking about their kindness, so eager to share their experience of natural beauty with a complete stranger.

When I climb down to the base of the falls, I have the whole ravine to myself. Down there, after the sun has dipped behind the cliffs and the gentle cascade pours into a pool covered with gold oak leaves, it is easy to imagine you've stumbled upon a still-hidden secret.

———— ♦ ————

TREES AND SHRUBS: bear oak, yellow birch, river birch, flowering dogwood, eastern redcedar, mountain laurel, sourwood, flame azalea, Catawba rhododendron, great laurel, black locust, American beech, chestnut oak, rock chestnut oak, willow oak, northern red oak, black oak, dwarf witch-alder, black walnut, cucumber magnolia, bigleaf magnolia, white ash, American ash, Table Mountain pine, pitch pine, eastern hemlock, Virginia pine, Carolina hemlock, sycamore

SMALLER PLANTS: Hercules club, ginseng, Virginia snakeroot, mountain spleenwort, white snakeroot, Tennessee aster, green-and-gold, sweet Joe-pye-weed, rattlesnake hawkweed, sweet goldenrod, galax, beetle-weed, St. John's wort, yellow iris, dwarf iris, Virginia blue flag, American lily-of-the-valley, orange daylily, large-flower trillium, beargrass, turkey beard, wood anemone, wild columbine

FUNGI: gray bolete, the old man of the woods, cinnabar chanterelle, yellow morel, fly agaric, chlorine amanita, false turkey tail, honey mushroom, jack-o'-lantern mushroom, orange jelly cap, turkey tail

MAMMALS: muskrat, raccoon, eastern cottontail, eastern chipmunk, coyote, beaver, bobcat, northern river otter, white-tailed deer, southern flying squirrel, gray fox, black bear, striped skunk

REPTILES AND AMPHIBIANS: Appalachian seal salamander, Blue Ridge dusky salamander, southern leopard frog, copperhead, yellow rat snake, corn snake, timber rattlesnake, northern spring peeper, upland chorus frog, eastern cricket frog, pickerel frog, red-spotted newt

BIRDS: broad-winged hawk, peregrine falcon, common raven, black-throated green warbler, worm-eating warbler, hooded warbler, snow goose, black vulture, swallow-tailed kite, American kestrel, merlin, wild turkey, turkey vulture, Cooper's hawk, red-shouldered hawk, red-tailed hawk,

eastern screech-owl, great horned owl, ruby-throated hummingbird, white-eyed vireo, Carolina chickadee, Carolina wren, purple martin, cliff swallow, barn swallow, tufted titmouse, eastern bluebird, pine warbler, yellow-rumped warbler, field sparrow, song sparrow

Chapter 7
FEARFUL HEADWATERS

HAW RIVER

It is call'd Hau-River, from the Sissipahau Indians, who dwell upon this Stream, which is one of the main branches of the Cape-Fair…Here is plenty of good Timber, and especially, of a Scaly-bark'd Oak; And as there is Stone enough in both Rivers, and the Land is extraordinary Rich, no Man that will be content within the Bounds of Reason, can have any grounds to dislike it.
—John Lawson, A New Voyage to Carolina

The thickly forested floodplains and wetlands at the headwaters of the Haw River—the northernmost tributary of the mighty Cape Fear River—is unlike any of the wild places in this book. Wetlands are incredibly rare in the Piedmont, both in North Carolina and throughout the physiographic region, so Haw River State Park features one of the most hydric ecosystems you can find west of the Fall Line.

A half-hour's drive north of Greensboro, it's one of the newest state parks in North Carolina, having just opened to the public in 2005. Before the state bought the property, it was a private retreat center for the Episcopal Diocese of North Carolina.

These Haw River headwaters and wetlands sit atop the state's Titaniferous Iron Ore Belt, so it didn't take long for European settlers to drastically alter the landscape. During the "iron rush" of the eighteenth century, American colonists built iron ore mines along the banks of the river, removing massive amounts of raw magnetite and hematite from the earth before shipping it off to be smelted into the muskets that would arm colonists during the American Revolution. One of the iron ore pits that once lay a stone's throw

The Haw River a few miles downstream from Haw River State Park.

from Haw River State Park—Shaw Mine—even served as a campsite for Nathanael Greene, the Revolutionary War general for whom Greensboro and Greenville were named.

Over the next century, a large population of Quaker immigrants settled along the floodplains of the Haw River. Quakers were some of the staunchest abolitionists during America's era of slavery, and so the Underground Railroad once passed right through here until the end of the Civil War. A few decades later, the iron ore mines shut down permanently when rival mines in the Great Lakes region proved much more profitable.

Today, the majority of the park sits on the south banks of the Haw River's primary headwater, which is only eight feet wide at this point. Headwaters are the farthest-upstream sources of a river (though the actual absolute source of the Haw—and therefore the Cape Fear—lies west in Forsyth County). The dominant landscape here is a Piedmont alluvial forest: broad, mesic-to-hydric floodplains full of flood-tolerant flora like river birch, sycamore, box elder, green ash, red maple, swamp chestnut oak, brook-side alder and even spotted water hemlock.

A healthy population of North American beaver has also led to the formation of "semi-permanent impoundments": small ponds and micro-ecosystems created by beaver dams along the headwaters, attracting sun-loving, hydric plants that can't survive beneath a thick canopy, like alder, hibiscus, sedge, cattail and buttonbush.

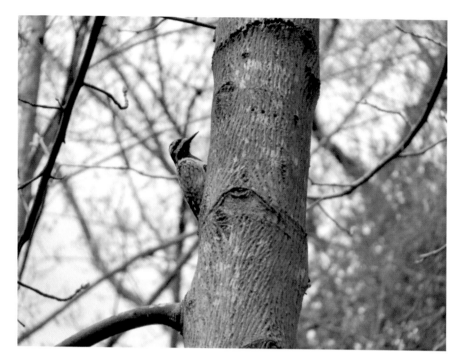

A yellow-bellied sapsucker. Note the holes in the bark.

In contrast, some of the steep, north-facing slopes along the riverbanks are home to a mesic mixed hardwood forest still recovering from last century's clearcutting and farming. The hardwood population here is a bit different from most of the state parks in this book, with a higher occurrence of beech, red oak and tulip tree, thanks to the more hydric soils. There's also a fairly large swamp on-site, which is virtually nonexistent in the Piedmont, but it's completely inaccessible at the moment.

In fact, the majority of the park isn't accessible yet, given how young the park is. There aren't any long hiking trails, but the short Piedmont Loop does provide a nice tour of a wetland ecosystem. Heading north from the Summit, the old Episcopalian retreat that now functions as an environmental education and conference center, you can walk through a pocket of wetlands along a boardwalk. Nestled between two steep slopes along the south bank of the Haw River, the boardwalk meanders through a partially flooded forest of tall, twisting trees and a thick, colorful understory. The wooden path over the water brings to mind Congaree National Park (minus the massive cypress trees) or even the imaginative worlds of *Myst* and *Riven*.

The scaly bark of white pine (*pinus strobus*).

While most of the park's natural treasures remain inaccessible today, the Department of Environment and Natural Resources' master plan for the park will add hiking trails, canopy walkways and camping sites, as well as additional boardwalks and overlooks to make the wetlands' dynamic ecosystems more visible. The state-spanning Mountains-to-Sea Trail—which will eventually run all the way from Clingman's Dome at the top of Great Smoky Mountains National Park to Jockey's Ridge State Park in the Outer Banks—will run straight through the park along the south bank of the Haw River once it's completed. A visitor center with exhibit halls and a small astronomical observatory to take advantage of the site's dark night skies are also in development.

———— ◆ ————

TREES AND SHRUBS: American hornbeam, black willow, black haw, black tupelo, sycamore, red maple, box elder, green ash, river birch, yellow birch, brook-side alder, pawpaw, swamp chestnut oak, white oak, ironwood,

tulip tree, red oak, sourwood, redbud, American beech, American holly, mapleleaf viburnum, winged elm, white mulberry, red mulberry, southern magnolia, cucumber magnolia, mockernut hickory, shagbark hickory, pecan, sweet gum, honey-locust, persimmon, Japanese honeysuckle, trumpet honeysuckle, spotted water hemlock, white pine, shortleaf pine, loblolly pine, Virginia pine

SMALLER PLANTS: bloodroot, spotted wintergreen, New York fern, Virginia bluebells, cardinal flower, eastern yellow stargrass, little sweet trillium, hairy arrowhead, jack-in-the-pulpit, spotted starthistle, sand coreopsis, woodland sunflower, May apple, Christmas fern, skunk cabbage, scuppernong, cranefly orchid, Indian pipe, beargrass, crested dwarf iris, St. Andrew's cross

FUNGI: flaming gold bolete, orange birch bolete, frost's bolete, the old man of the woods, massed lesser inky cap, bisporous destroying angel, Coker's amanita, yellow-orange fly agaric, dead man's fist, cinnabar chanterelle, lobster mushroom, orange pinwheel, Caesar's mushroom, turkey tail, indigo milk mushroom

MAMMALS: coyote, bobcat, black bear, river otter, white-tailed deer, southeastern shrew, woodchuck, gray fox, striped skunk, eastern red bat, Virginia opossum, North American beaver, muskrat

REPTILES AND AMPHIBIANS: eastern river cooter, northern fence lizard, four-toed salamander, mole salamander, gray treefrog, northern spring peeper

BIRDS: wood duck, red-shouldered hawk, brown creeper, fox sparrow, ruby-throated hummingbird, Canada goose, song sparrow, eastern bluebird, great blue heron, little blue heron, green heron, black culture, turkey vulture, wild turkey, blue-winged teal, northern pintail, ruddy duck, sharp-shinned hawk, Cooper's hawk, red-tailed hawk, American kestrel, merlin, barn owl, great horned owl, Acadian flycatcher, loggerhead skrike, blue jay, purple martin, eastern kingbird, Carolina wren, black-and-white warbler, hooded warbler, European starling, pine warbler, prairie warbler, eastern towhee, dark-eyed junco, bufflehead, white-winged scoter, northern flicker, pileated woodpecker, yellow-bellied sapsucker, red-headed woodpecker, Carolina chickadee, brown-headed nuthatch, golden-crowned kinglet, ruby-crowned kinglet, yellow-breasted chat, orchard oriole

AN INLAND SEA

LAKE NORMAN

Water has its own archaeology, not a layering but a leveling, and thus is truer to our sense of the past, because what is memory but near and far events spread and smoothed beneath the present's surface.
—*Ron Rash,* Nothing Gold Can Stay

For hundreds of thousands of years, the Catawba River ran unimpeded from its headwaters in the Blue Ridge Mountains near Asheville, east and then south past Charlotte, all the way to Lake Marion in the South Carolina Lowcountry. European settlers named the river after the Catawba tribe, whose towns peppered the riverbanks east of their bitter enemies, the Cherokee. Eventually, the Catawba were forced to abandon the vast majority of their homeland along the river, thanks to smallpox and the encroachment of European settlers (today, their descendants can be found on a small reservation near Rock Hill, South Carolina). In their wake, Europeans clearcut the floodplains of the Catawba River to make room for homesteads and farms.

But in the early twentieth century, Duke Power (now Duke Energy) began building dams along the Catawba River to generate hydroelectric power for the ever-growing Piedmont Crescent. Between 1959 and 1965, it built one of the newest dams twenty miles north of Charlotte at Cowan's Ford, the site of a historic battle during the Revolutionary War where Nathanael Greene and William Lee Davidson (for whom Davidson, North Carolina, and Davidson College are named) attempted to stop Lord Cornwallis's troops from crossing the Catawba (they failed).

The dam at Cowan's Ford created a 32,500-acre reservoir, the largest man-made body of fresh water in North Carolina. Duke Power, forgoing the river's Native American namesake, decided to call it Lake Norman after its former president, Norman Cocke. In creating Lake Norman, the company buried not only the site of the Battle of Cowan's Ford but also entire towns—mills, churches, bridges, cemeteries, homesteads and farms. They lie abandoned in the dark beneath three trillion gallons of water.

Today, North Carolina's "inland sea" is Charlotte's version of Beverly Hills, home to the McMansions of NASCAR stars and megachurch pastors. Public access is exceedingly rare, except on a solitary peninsula—finely lobed like an oak leaf—at the northern end of the lake. This is Lake Norman State Park (see color insert, figure 13), donated by Duke Power in 1962.

When I arrive at the park on a humid afternoon in early September, I'm stunned by its quietude. Even this close to Charlotte and Interstate 77, the only sound I hear is the music of cicadas. I follow a trail through a mixed hardwood forest, skirting the shores of the lake and passing through a series of oak-hickory coves. Spider webs arc over my head, and harvestman spiders scurry over the trail; as a child I knew them as "granddaddy longlegs," and they haunted my darkest nightmares. Downy tulip tree seeds drift through the air like September snow, along with dangling caterpillars that seem to defy gravity. A solitary insomniac cricket pauses his singing out of caution as I pass by, and an inquisitive hornet is drawn to the sweat on the back of my neck.

Walking through these coves, I gaze through the trees at the lake and wonder: Who plowed these fields when they were farmland? Whose homes lie beneath the lake, choked with algae? What kind of men and women were they? What would they think of the notion of hiking, of walking through the woods to escape our air-conditioned, sedentary lives spent staring at screens?

I approach a dry rill, a small valley of life where rainwater drains into the lake. Moss and lichen and ferns cling to its moist sides (see color insert, figure 14). Two-colored bolete mushrooms erupt in bursts of red at the feet of oaks and holly saplings. Thanks to an epidemic infestation of southern pine beetles across the eastern United States from 1999 to 2002, there aren't as many pine trees here as there used to be. Female beetles locate a tasty stand of pines and release pheromones to attract males. As they begin to chew their way into the bark, pines will release sap in a desperate attempt to plug the hole and trap attacking beetles

A lakeside trail through one of Lake Norman's coves.

like the amber-bound mosquitos of *Jurassic Park*. Once inside, the beetles turn the trees into a labyrinthine nursery, killing them in the process.

But beetles aren't the only threat to the beauty and diversity of life at Lake Norman State Park. In December 2014, Duke Energy—the same electric power company that created Lake Norman and donated the land that became Lake Norman State Park—received approval from state regulators to dump water from a nearby coal ash pond into the lake in order to repair a cracked metal pipe beneath the pond at the Marshall Steam Station five miles south of Lake Norman State Park. Coal ash is a thick, black inky residue left over from coal combustion, and over 130 million tons of it are created by coal plants in the United States every year.

According to *Scientific American*, coal ash is "more radioactive than nuclear waste" and contains harmful heavy metals like arsenic, boron, chromium and mercury. In the past few years, Duke Energy has accidentally spilled millions of tons of coal ash at other locations in North Carolina—particularly the Dan River and Wilmington—and been fined for contaminating groundwater. Duke owns fourteen coal ash ponds in the state, including three near Lake Norman. In 2014, the company identified two hundred "seeps" where three million pounds of coal ash are leaking out of the ponds *every day*, including twenty-three seeps near the shores of Lake Norman.

If dumping water from a coal ash pond into Lake Norman—home of great blue herons, great egrets, wood ducks and beavers—doesn't bother you, consider this: the Catawba River and its reservoirs (Lake Norman, Mountain Island Lake and Lake Wylie) are the primary source of drinking water for the entire Charlotte area.

———— ◆ ————

Trees and Shrubs: American holly, mapleleaf viburnum, brook-side alder, river birch, Japanese honeysuckle, eastern redcedar, flowering dogwood, persimmon, mountain laurel, sourwood, eastern redbud, American beech, white oak, Spanish oak, willow oak, northern red oak, sweet gum, white hickory, mockernut hickory, black walnut, Virginia pine, loblolly pine, red maple

Smaller Plants: white heath aster, spiny amaranth, fireweed, small wood sunflower, spotted cat's ear, bluestem goldenrod, spotted jewel-weed, cardinal flower, Virginia day-flower, Christmas fern, prairie senna, evening primrose

Fungi: oyster mushroom, turkey tail, false turkey tail, birch-bark bolete, weeping willow, fly agaric, dead man's fist, witch's butter, scarlet waxy cap, devil's snuff box, indigo milk mushroom

Mammals: white-tailed deer, North American beaver, eastern chipmunk, eastern cottontail, red fox, gray fox, raccoon, woodchuck, eastern red bat, Virginia opossum

Reptiles and Amphibians: eastern American toad, eastern box turtle, eastern snapping turtle, northern fence lizard, five-lined skink, black rat snake, northern water snake, mole kingsnake, eastern garter snake, copperhead

Birds: great blue heron, great egret, snow goose, Canada goose, hooded merganser, bufflehead, wood duck, mute swan, black vulture, turkey vulture, mallard, common loon, American redstart, black-and-white warbler, ring-billed gull, wild turkey, downy woodpecker, eastern screech owl, great horned owl, blue-headed vireo, horned grebe, red-tailed hawk, red-shouldered hawk, killdeer, Carolina chickadee, red-breasted nuthatch, blue jay, red-eyed vireo, red-bellied woodpecker, northern flicker, belted kingfisher

Chapter 9
HIDDEN BEAUTY

MAYO RIVER

The map had been the first form of misdirection, for what is a map but a way of emphasizing some things and making other things invisible?
—*Jeff VanderMeer*, Annihilation

Deep in a forest of oak and hickory near the Virginia border lies the most beautiful waterfall east of the Blue Ridge Escarpment. A white veil of water gushes over a granite outcrop. The surrounding stone is stained with deep green liverworts, and the pool below is a perfect summer swimming hole. This is Fall Creek Falls, and it's the Piedmont's answer to Turtleback Falls in Gorges State Park, deep in the Blue Ridge Mountains.

There's just one problem. No one knows it's here.

Fall Creek Falls is on one of many scattered plots of land that compose Mayo River State Park, forty-five minutes north of Winston-Salem and Greensboro. And technically, there's a trailhead and a quarter-mile footpath to Fall Creek Falls a few miles off U.S. 220 on Deshazo Mill Road. But you won't find the trail, or the falls, on any maps or brochures for Mayo River State Park.

Right now, the only access to the park is 9.0 miles south, after Fall Creek has merged with the Mayo River, where a single 1.8-mile hiking trail ventures into the woods from a handsome visitor center. Along with Haw River State Park (see chapter 7), Mayo River State Park was purchased by the state in 2003 as part of the "New Parks for a New Century" initiative. But as of 2015, five years after officially opening as a state park, the Mayo is still mostly hidden and inaccessible.

A tufted titmouse pokes out of its nest in the hollow of a tree.

For starters, there is no public access to the river. And even if there were, two dams alongside this southern part of the park would prevent paddlers from getting anywhere interesting. It's farther upstream—on the stretch of the river between the Virginia state line and U.S. 220—that the state wants to open up to more kayaks, canoes and rafts in the future, thanks to some class II and III rapids reminiscent of the Nantahala River in the mountains.

Named after Major William Mayo—an English engineer who designed the city of Richmond, Virginia, in 1737—the Mayo River rises in southern Virginia before crossing into North Carolina as a tributary of the Dan River, which it flows into a few miles south of the state park. Native Americans were living on the banks of the Mayo long before the arrival of European settlers. In fact, if you paddle the Mayo in a kayak or canoe today, you'll pass the remnants of Native American fish traps. Look for tree branches jutting up out of the water like a partially submerged fence. Fish would be pulled behind the trap by a well-placed obstacle, where the river's current would keep them from escaping.

After Native Americans had been driven out of the region, the site was home to a plantation, a school and gristmills. Then, in the 1890s, Colonel Frances Fries built two hydroelectric dams along the river to power nearby cotton mills. Needless to say, the entire river corridor was clearcut at some point over the past three hundred years in the name of human industry. Today, its floodplains are in the process of returning to a mature forest.

Beneath the river and the trees lies the metamorphic bedrock of the Piedmont plateau, created during the Allegheny or Appalachian orogeny 300 million years ago when ancient continents collided to create a

massive, Alp-like mountain range. Because the gneiss, schist and granite beneath the present-day Mayo River is relatively supple, no remnants of those mountains remain here (unlike the tougher quartzite remnants—or monadnocks—found at other state parks in the Piedmont).

The jewels of Mayo River State Park, then, are primarily ecological instead of topographical, an interesting mix of Piedmont mesic and coastal mesic forests so far from the coast. The low-lying floodplains are covered with beech, river birch, green ash and other flood-tolerant hardwoods like black tupelo and southern sugar maple. Some of the higher elevations, which offer some beautiful vistas of the river and surrounding plateau, are home to upland pine forests of Virginia, shortleaf and loblolly pine, at least for the next few decades until they're inevitably replaced by maturing hardwoods (see the discussion of ecological succession in chapter 5).

Finally, the north-facing slopes that descend to meet the southern banks of the river are cooler and wetter than the surrounding uplands, thanks to their geographic aspect (in the northern hemisphere, north-facing slopes receive less direct sunlight). As a result, thickets of mountain

A white-throated sparrow.

laurel and Catawba rhododendron blanket the understory, along with occasional dogwoods and redbuds. On these slopes and throughout the park, stone outcrops occasionally burst from the leaf litter and provide a home for lichens.

Just twenty miles east of Mayo River State Park lies Duke Energy's Dan River Steam Station, site of the third-largest coal ash spill in the history of the United States. In February 2014, an unlined pond of toxic coal ash—located right on the north bank of the Dan River—spilled nearly forty thousand tons of ash directly into the river, along with twenty-four million gallons of wastewater. According to the *Charlotte Observer*, "The accident never should have happened. Duke knew of the dangers of coal ash and the potential for a breach. The utility had seen the TVA spill, the worst ever, across the state line in Tennessee in 2008. It was easier, though, to focus on shutting down power plants around the state while leaving the coal ash in place and hoping for the best."

Luckily, the spill occurred upstream of the Dan River's confluence with the Mayo River, so the state park's river corridor was unaffected. But a year later, in February 2015, "more than 90 percent of the ash remains in the [Dan River] riverbed, and it is far too early to know what effect those thousands of tons will have over the long term."

Years from now, instead of a hidden gem, Mayo River State Park may well be one of the most popular parks in the Piedmont, once Fall Creek Falls and those class III rapids are opened up to visitors. Until then, it's the most beautiful corner of the Piedmont that nobody's enjoying.

————— ◆ —————

TREES AND SHRUBS: brook-side alder, trumpet honeysuckle, Japanese honeysuckle, flowering dogwood, pawpaw, mapleleaf viburnum, American holly, sweet birch, river birch, American hornbeam, American hazelnut, elderberry, Catawba rhododendron, pink azalea, eastern redcedar, sourwood, persimmon, eastern redbud, honey-locust, American beech, white oak, scarlet oak, Spanish oak, chestnut oak, willow oak, black oak, sweet gum, pignut hickory, shag-bark hickory, sassafras, black walnut, tulip tree, white ash, green ash, shortleaf pine, longleaf pine, white pine, Virginia pine, loblolly pine, eastern hemlock, peach, black cherry, American plum, red maple, winged elm, scuppernong

SMALLER PLANTS: periwinkle, May apple, long-stalked aster, Christmas fern, crested dwarf iris, American trout-lily, daffodil, bloodroot, northern maidenhair-fern, spotted wintergreen, round-lobed hepatica, windflower, rambler rose, woolly blue violet, Carolina petunia, jack-in-the-pulpit, yellow thistle, Joe-pye-weed, Virginia creeper

FUNGI: destroying angel, witch's butter, earthstar, fly agaric, oyster mushroom, spotted cortinarius

MAMMALS: North American beaver, coyote, hairy-tailed mole, eastern mole, big brown nat, eastern red bat, eastern cottontail, red fox, gray fox, muskrat, raccoon, striped skunk, bobcat, American mink, northern river otter, white-tailed deer

REPTILES AND AMPHIBIANS: mole salamander, northern spring peeper, eastern cricket frog, upland chorus frog, pickerel frog, American bullfrog, red-spotted newt, eastern snapping turtle, eastern painted turtle, eastern river cooter, eastern box turtle, northern black racer, black rat snake, eastern garter snake, northern fence lizard

BIRDS: wood duck, belted kingfisher, dark-eyed junco, raven, white-throated sparrow, wild turkey, Kentucky warbler, yellow-rumped warbler, downy woodpecker, yellow-bellied sapsucker, brown-headed nuthatch, eastern bluebird, American woodcock, gadwall, blue-winged teal, northern bobwhite, little blue heron, green heron, hooded merganser, northern harrier, osprey, Cooper's hawk, red-tailed hawk, red-headed woodpecker, blue jay, raven, purple martin, tree swallow, northern mockingbird, magnolia warbler, American redstart, bobolink, pine siskin, American goldfinch, evening grosbeak, brown-headed catbird, eastern meadowlark, indigo bunting

Chapter 10
FALL LINE WINE

MEDOC MOUNTAIN

At some point, probably around the turn of the century, Garrett had come up with a new name for his white, sweet Scuppernong wine that gave it a special identity and a special fitness for promotion. Since the Scuppernong could claim to be the original white American grape, the first of the native grapes that the first English settlement knew, he would call its wine after the first-born white child in the new world: Virginia Dare.
—*Thomas Pinney,* The Makers of American Wine

Over 300 million years ago, magma cooled and crystallized into a granite mountain sixty miles northeast of present-day Raleigh, although "mountain" is a generous term. Medoc Mountain is only 325 feet high, and unlike granitic "plutons" elsewhere in North Carolina—Stone Mountain and Forty Acre Rock—it's completely covered in trees, so there are no views of the surrounding area from the summit. But beneath that canopy of trees is a thriving series of ecosystems and recovering forests, and a diverse array of wildlife.

The park sits right on the state's Fall Line, where the tougher metamorphic rock of the western two-thirds of the state gives way to the soft sedimentary rock of the Coastal Plain. All the land east of the Fall Line has been created over the past 300 million years by sediments carried downstream from the Blue Ridge Mountains and the Piedmont and deposited on the coast, where they're compacted over time. And so here, at the dividing line between the Piedmont and the Coastal Plain, you'll find

rocky outcrops of metamorphic granite on the slopes of Medoc Mountain, since the softer sedimentary rocks around them have eroded much faster.

For over one hundred years, Medoc Mountain and the surrounding floodplains of Little Fishing Creek were home to one of the best-known vineyards in the United States. In the early 1800s, the first owner of the vineyards, Sidney Weller, named the site after Médoc, his favorite wine-growing region of France, just north of Bordeaux. Weller developed a way to make wine using North Carolina's local scuppernong (muscadine) grapes during a period in history when almost all wines were imported from Europe. Weller's successor, Paul Garrett, took the idea and ran with it, creating the most popular, best-selling wine in America during the early years of the twentieth century: Virginia Dare, a sweet scuppernong hybrid named after the first English child born in the American colonies.

You can still buy Virginia Dare wine today, and most of the vineyards in North Carolina's thriving wine industry still make scuppernong hybrids. If you know what to look for, you can still find wild scuppernong vines in the floodplains of Medoc Mountain State Park. Its leaves are roundish or spade-

A Carolina wren belting out its song.

shaped and thickly serrated, and the grapes are almost perfectly spherical and bright green until late summer, when they ripen and turn dark purple. In the wild, the vines grow in fairly thick sheets in the understory and could easily be mistaken for a large shrub.

The vineyards at Medoc closed in the 1940s, and so the park today is a verdant river corridor of Little Fishing Creek, a mixture of low-lying floodplains and the steep, mesic slopes of Medoc Mountain.

As I've mentioned in earlier chapters, the vast majority of the Piedmont's wild spaces are still recovering from human impact over the past three hundred years, when virtually all of the region's forests were clearcut for farmland or logged for timber. This recovery process is called ecological succession (see chapter 5), and nowhere in the region is it more evident than Medoc Mountain.

Young successional forests of loblolly, shortleaf and Virginia pine can be found in the more mesic corners of the park today, since those acres were farmland and vineyards up until the 1940s. Many were logged and disturbed even more recently in the 1960s, thanks to the discovery of molybdenum—a valuable component in the production of steel—on the slopes of Medoc Mountain. Over the next one hundred years, these pines will mature. Most will die from disease or southern pine beetle infestations and be replaced by hardwoods like oak and hickory, seedlings and saplings of which are already growing now, awaiting their day in the canopy. Other mesic areas are already filled with a mix of more mature hardwoods and pines, indicating they've had more time to recover from human activity.

The lower elevations of the park, particularly on the west side of the river, are home to bottomland forests of flood-tolerant river birch, sweet gum, water oak, ironwood, brook-side alder and even swamp chestnut oak. These hydric areas are home to great blue and green herons and attract a wide variety of migratory songbirds in the summer, like warblers and tanagers. The river itself—Little Fishing Creek—is sluggish and docile, perfect for first-time paddlers.

Despite its modest elevation, the steep trail to the summit of Medoc Mountain does feel like a hike in the Blue Ridge Mountains, thanks to the westernmost incidences of mountain laurel and chestnut oak in the state, along with some granite outcrops laced with quartz. At the summit, look for the concrete ruins of a dancing hall from the 1920s. I can't help but picture a Jazz Age version of *Dirty Dancing*, which was actually filmed just outside Chimney Rock State Park at Lake Lure, near Hendersonville, North Carolina. It's strange to imagine flappers with bob haircuts and slim

The early spring blooms of southern crabapple.

skirts here in the quiet forest, dancing the Charleston to the music of Ella Fitzgerald and Count Basie, joining men in double-breasted waistcoats at a party fit for *The Great Gatsby*, as oblivious to the oncoming Great Depression as the trees and birds were to the European settlers, farmers and winemakers who razed their homes on the slopes below.

———————◆———————

TREES AND SHRUBS: American holly, American elm, sugar maple, Carolina willow, mountain laurel, black walnut, sassafras, southern magnolia, flowering dogwood, sycamore, mapleleaf viburnum, pawpaw, river birch, Japanese honeysuckle, trumpet honeysuckle, elderberry, eastern redcedar, honey-locust, white oak, water oak, swamp chestnut oak, scarlet oak, black oak, sweet gum, pignut hickory, shagbark hickory, tulip tree, eastern hemlock, shortleaf pine, loblolly pine, Virginia pine, Chickasaw plum, peach, black cherry, red maple

SMALLER PLANTS: scuppernong, common butterfly-weed, Virginia heartleaf, oxeye daisy, May apple, trumpet creeper, Chinese wisteria, pointed blue-eyed-grass, yellow trout-lily, atamasco lily, orange daylily, pink lady's-slipper, downy flox, spotted wintergreen, broadleaf arrowhead, flameleaf sumac, goldenrod

FUNGI: cedar apple rust, witch's butter, Caesar's mushroom, cinnabar chantarelle, crown-tipped coral fungus

MAMMALS: North American beaver, eastern cottontail, black bear, northern river otter, southern short-tailed shrew, bobcat, white-tailed deer, red fox, gray fox, coyote, Virginia opossum, raccoon, tricolored bat

AMPHIBIANS AND REPTILES: Carolina mudpuppy, northern black racer, eastern worm snake, eastern hog-nosed snake, corn snake, northern rough green snake, black rat snake, northern red-bellied snake, eastern garter snake, copperhead, eastern box turtle, northern fence lizard, cricket frog, Cope's gray treefrog, eastern red-backed salamander, Neuse River waterdog, American bullfrog

BIRDS: sharp-shinned hawk, red-shouldered hawk, turkey vulture, black vulture, ruby-throated hummingbird, chuck-will's-widow, northern bobwhite, double-crested cormorant, Mississippi kite, red-tailed hawk, broad-winged hawk, peregrine falcon, American kestrel, great horned owl, barred owl, prairie warbler, belted kingfisher, barn swallow, gray catbird, purple finch, American goldfinch, Baltimore oriole

Chapter 11
ARMORY OF THE SOUTHEAST

MORROW MOUNTAIN

*From the vestiges left here by the indians it must have been a place much
frequented by them. They have now all disappeared from about here. Some fifty
years ago, however, bands of ten or more were frequently met with on their way to
Fayetteville, armed with bows and arrows, and ready for a reward to display their
dexterity in hitting, before it came down, a piece of coin tossed up in the air.*
—*Francis J. Kron, 1875*

Just east of Albemarle, the state-spanning Yadkin River makes a sharp
turn southward and instantaneously becomes the Pee Dee River
before crossing the South Carolina border and running all the way to the
Atlantic. At this decisive turn, the Yadkin–Pee Dee separates the outskirts
of Albemarle from the vast Uwharrie National Forest (see chapter 21),
the long-eroded remnant of what was once a twenty-thousand-foot coastal
mountain range hundreds of millions of years ago. In the eons since,
sediments have pushed the coast another two hundred miles east, and the
mountains have all disappeared—all except for a cluster of battered peaks
overlooking the western banks of the river, the present-day boundaries of
Morrow Mountain State Park. The reason these mountains alone survived
is the same reason they were so valuable to Native Americans for twelve
thousand years. It's why Morrow Mountain, in particular, was one of the
greatest pre-colonial armories in the eastern United States.

Think of Morrow Mountain as the Mount Doom of the mid-Atlantic—
the fiery peak where Sauron forged all of his greatest weapons in *The Lord*

of the Rings. Of course, there wasn't anything evil about Morrow Mountain, but it was a major source of arrowheads, spear heads, knives and other stone tools—not just in the Piedmont or the Carolinas but throughout the region—thanks to a substance called rhyolite, a tough but malleable volcanic rock highly prized by Native American masons for twelve thousand years. As the ancient Uwharrie Mountains eroded away, the rhyolite here was exposed, along with other erosion-resistant minerals like quartzite, basalt and argillite.

Driving into the park from the west, no mountains appear on the horizon. But don't be fooled; their slopes just aren't as steep on this side, and their summits are hidden behind foothills. In early March, the first thing I notice after passing through the park gate is the low stone walls on either side of the road. I assume they're slate, since Morrow Mountain sits atop the Carolina Slate Belt that composes the eastern half of the Piedmont, but I'll soon find out I'm wrong.

To reach the park office, I pass through a hilly maze of mixed hardwoods dominated by hickory and oak, still gray and bare in the first week of March, as if the trees have all been turned upside-down and their roots are thrusting up toward the sky. The forest floor is relatively open and still covered with crisp brown leaves from the previous fall. Quartzite boulder fields dot a few hillsides, and flocks of deafening motorcycles meet me at every turn in the road.

Inside the park office, a tall, silver-haired man helps a family of four find the trail they're looking for on a map. Greg Schneider, the park's superintendent, invites me back to his office—the facility's former boiler room—to talk about Morrow Mountain. I ask him about rocks first, since that's what drew people here twelve thousand years ago and since I'd seen so many stone walls and structures on my way in.

"That's argillite," Schneider says, referring to the smooth, dark stone I'd mistaken for slate (for the record, argillite can metamorphose *into* slate under the right conditions). You may know argillite as the carving medium favored by native Haida artisans in the Pacific Northwest, but here at Morrow Mountain, it served a more utilitarian purpose for European settlers and American masons. "Almost all of the facilities here were built with local materials by the Civilian Conservation Corps and the Works Progress Administration seventy years ago," Schneider says, "including the building we're sitting in right now. The argillite was quarried right here in the park."

Today, you can still explore this argillite quarry by taking the half-mile Quarry Trail on the northern side of the park. The other quarry—the ancient rhyolite one used by Native Americans—was located near the

summit of Morrow Mountain at the southern end of the park but is no longer there.

The majority of the park, then, lies between these two quarries. The lower elevations are laced with streams that run east to the Yadkin–Pee Dee and are filled with northern spring peepers, marbled salamanders and other slippery amphibians. The higher slopes of the park's four major peaks—Fall Mountain, Sugarloaf Mountain, Hattaway Mountain and the eponymous Morrow Mountain—are covered in Piedmont monadnock forest with a canopy of chestnut oak and other oaks. Regardless of elevation, one fauna you're almost guaranteed to see at Morrow Mountain, if you're quiet and observant enough, is white-tailed deer.

White-tailed deer occupy every state park in the Piedmont, but Morrow Mountain's five thousand acres are home to over six hundred deer. "Without natural predators, the population has exploded," Schneider says. "If you walk around the park, you'll see a lack of herbaceous growth near the ground." There's simply not enough sustenance on park grounds to sustain such a huge population, and with the encroachment of urban sprawl from the outskirts of Charlotte, the deer have nowhere to go.

Some forest preserves facing similar conditions, like those on the outskirts of Chicago, Illinois, have begun instituting deer culling initiatives, where hunters and sharpshooters are paid by the state to reduce the population. Of course, this method has proved controversial with citizens and wildlife advocates. "We're not doing any culling," Schneider assures me, "but we are transferring some of them to the Cherokee reservation."

The town of Cherokee—over two hundred miles west of Morrow Mountain, right at the foot of Great Smoky Mountains National Park—is both an Indian reservation and one of the state's largest tourist attractions. "Deer are very important to the Cherokee culture, but they don't have a huge population anymore because their deep cove woods are all that's left," Schneider says, referring to the heavy tourist- and resident-related development of the reservation's flatter terrain. "More recently, they've made vast improvements by restoring more open places and food plots in the hopes of growing a healthier deer population. We've partnered with the Cherokee and the National Park Service to live-trap white-tailed deer here and then transport them to the reservation." So while the rhyolite quarries have all dried up—along with the demand for stone weaponry and tools—Morrow Mountain is still providing for Native Americans to this day.

Before exploring the rest of the park, I ask Superintendent Schneider what challenges he and his staff face most. "We're the third-oldest state park

in North Carolina," he says. "Some of the walls are crumbling. And nobody has the skills to fix them anymore. Modern masons don't face-cut raw rock like they used to. All of our facilities are starting to reach the end of their lifespan, so we spend the majority of our time repairing everything. In this age of tight budgets, we won't get it done in the next few years. It will take decades unless there's a major investment coming that I don't know about."

After thanking the superintendent for his time, I spend the rest of the afternoon driving and walking through the park. In addition to the aforementioned quarry, it's quickly evident that humans—and nature—have made major impacts on the landscape. Some of the park's hillsides are a catastrophic tangle of deadfall thanks to recent and not-so-recent storms. Morrow Mountain is far enough east to have taken a beating from Hurricane Hugo and Hurricane Fran, as well as tornados, ice storms and harsh winds. Thankfully, downed trees actually play a benevolent role in the life of a forest by opening up the canopy, thereby allowing more sunlight to reach new and herbaceous growth closer to the ground. Over time, these fallen trees also become nursery logs. Like stars gone supernova, they pass on their nutrients to new forms of life.

Near the worst of the storm damage lies a clearing frozen in time. In the valley between Hattaway Mountain and Fall Mountain stands a nineteenth-century timber-frame homestead surrounded by clumps of daffodil; a broad, arching magnolia; a water well; and a greenhouse (see

A nursery log, probably toppled by Hurricane Fran.

A massive southern magnolia a few yards away from the Kron homestead.

color insert, figure 15). Though the original structures were destroyed in the 1950s, these buildings are an accurate restoration of Attaway Hill, the home of Dr. Francis J. Kron, beginning in 1834. Born in Prussia, Dr. Kron was one of the first European settlers to live on Morrow Mountain, along with his wife and daughters. Dr. Kron was a renowned physician and horticulturist, and Attaway Hill served as a combination home, hospital and pharmacy, with room for patients to stay overnight.

Dr. Kron's medical techniques may seem barbaric today—bloodletting, blistering, mercury and turpentine ingestion—but they were standard practice at the time. Not so standard was his horticulture: Dr. Kron performed experiments for the Smithsonian Institute and was one of the pioneers of grafting, where the bud of one species is inserted into another. His greenhouse was regarded as one of the most extensive in the New World, containing "almost every vegetable known in the country at the time," as well as 107 varieties of grape from the Luxembourg Gardens of Paris.

Lest you begin to romanticize the Kron family's life here at Morrow Mountain, it's important to remember that they owned slaves, though you won't see them mentioned in any of the park's literature. Dr. Kron's daughters never married "because of their father's disapproval of local men." After Dr. Kron's death, having lost most of their land and money, they were cared for by the descendants of their former slaves.

Leaving the homestead behind—happy to live in an era without slavery, bloodletting or turpentine medication—I finally head for the higher elevations of the park. The summit of Morrow Mountain is actually accessible by car; pull it up on Google Earth and you'll see a black crown of asphalt. Earlier that day, Superintendent Schneider had gushed about the views from the summit, so I'm optimistic, despite my reservations about "drive-thru summits." On the one hand, they're accessible to everyone, regardless of age or ability. On the other, they can turn a beautiful ecosystem—like the one atop Crowders Mountain (see chapter 4)—into a parking lot, choked with exhaust and cigarettes.

I can't tell you about the views from the summit of Morrow Mountain. Not in any detail, at least. I glimpse them briefly through the passenger window of my car, and they do appear impressive. But it's a beautiful Sunday, and the parking lot at the summit is completely full. There are literally hundreds of motorcycles, many of them still running. The low argillite walls overlooking the eastern viewshed are lined with people like crows on a power line, smoking and eating fast food.

I understand the impulse to climb high and look down on the world. It is a human urge at least as old as Etemenanki, the Babylonian ziggurat that may have inspired myths of a Tower of Babel. But overlooks reinforce the illusion that nature is something "out there," separate and distant from us.

The view from the road on the way to the Morrow Mountain overlook.

Overlooks encourage us to see mountains and forests through a frame. How much can we learn about the idiosyncrasies of sea life by staring through the glass of an aquarium?

Looking down on the Piedmont from the parking lot atop Morrow Mountain, you can't see the iridescent breast of a common grackle. You can't hear the symphony of upland chorus frogs after an evening rain. You can't appreciate the subtle architecture of oaks.

The natural world is not as far away as it appears from an overlook. And we are no closer to it standing in a parking lot—atop a mountain or not—than we are sitting in front of our televisions.

TREES AND SHRUBS: southern magnolia, cucumber magnolia, tulip tree, pink azalea, pawpaw, mountain holly, black holly, American holly, American hazelnut, American hornbeam, river birch, brook-side alder, Japanese honeysuckle, trumpet honeysuckle, elderberry, flowering dogwood, silky dogwood, persimmon, blueberry, sourwood, mountain laurel, white oak, scarlet oak, chestnut oak, willow oak, northern red oak, black oak, American beech, American chestnut, American witch-hazel, sweet gum, shagbark hickory, bitter-nut hickory, mockernut hickory, sassafras, black tupelo, white ash, green ash, shortleaf pine, longleaf pine, loblolly pine, Virginia pine, Chickasaw plum, black cherry, red maple, box elder, sugarberry, winged elm, scuppernong

SMALLER PLANTS: May apple, Christmas fern, Asiatic dayflower, Chinese wisteria, atamasco lily, downy arrowwood, woodland sunflower, purple-disk sunflower, sweet Joe-pye-weed, oxeye daisy, orange coneflower, bluestem goldenrod, long-stalked aster, cardinal flower, Virginia dayflower, St. John's wort, St. Andrew's cross, dwarf iris, cinnamon fern, bloodroot, witchgrass, crabgrass, mountain phlox, wood anemone, Carolina rose, swamp rose, Virginia creeper

FUNGI: American Caesar's mushroom, elegant stinkhorn, jack-o'-lantern mushroom, turkey tail, false turkey tail, crowded parchment, ceramic parchment, split gill

MAMMALS: white-tailed deer, Virginia opossum, striped skunk, raccoon, eastern red bat, silver-haired bat, hoary bat, big brown bat, Mexican free-

tailed bat, North American beaver, muskrat, eastern cottontail, coyote, red fox, gray fox, bobcat, northern river otter

AMPHIBIANS AND REPTILES: marbled salamander, spotted salamander, northern dusky salamander, dwarf salamander, northern red salamander, American toad, Fowler's toad, pickerel frog, American bullfrog, upland chorus frog, striped southern chorus frog, green treefrog, northern spring peeper, southern leopard frog, eastern snapping turtle, eastern painted turtle, eastern river cooter, eastern box turtle, yellow-bellied slider, northern scarlet snake, eastern kingsnake, corn snake, black rat snake, queen snake, eastern garter snake, copperhead, timber rattlesnake, northern fence lizard, broad-headed skink, green anole

BIRDS: bald eagle, summer tanager, scarlet tanager, prothonotary warbler, great crested flycatcher, great blue heron, green heron, belted kingfisher, mallard, wild turkey, turkey vulture, eastern Phoebe, American wigeon, wood duck, blue-winged teal, hooded merganser, ruddy duck, northern bobwhite, woodstork, horned grebe, common loon, wild turkey, double-crested cormorant, American bittern, great egret, snowy egret, black-crowned night-heron, yellow-crowned night-heron, black vulture, osprey, red-tailed hawk, red-shouldered hawk, Cooper's hawk, broad-winged hawk, merlin, peregrine falcon, American kestrel, American coot, Virginia rail, ruby-throated hummingbird, barn owl, eastern screech-owl, great horned owl, barred owl, chimney swift, red-bellied woodpecker, yellow-bellied sapsucker, pileated woodpecker, purple martin, blue jay, fish crow, Carolina wren, European starling, cedar waxwing, Kentucky warbler, bobolink, red crossbill, American goldfinch, dark-eyed junco, pine siskin

FORTRESS OF TREES

PILOT MOUNTAIN

Upon the further side there rose to a great height a green wall encircling a green hill thronged with mallorn-trees taller than any they had yet seen in all the land. Their height could not be guessed, but they stood up in the twilight like living towers. In their many-tiered branches and amid their ever-moving leaves countless lights were gleaming, green and gold and silver.
—*J.R.R. Tolkien,* The Fellowship of the Ring

I can think of no better real-world Lothlórien than the forested peak of Pilot Mountain. And like Tolkien's fictional "Fortress of Trees," its iconic summit has inspired many stories.

According to Cherokee folklore, a race of immortal humans called the Nûñnë'hï lived in underground townhouses throughout the Piedmont. Like the *faerie* of Western Europe, the Nûñnë'hï could be malevolent tricksters or benevolent guardians, depending on the particular story being told, but they are credited in Cherokee mythology with defending the tribe from a variety of threats, hiding some of them away in the Blue Ridge Mountains during the Indian Removal of 1838 and fighting off a group of Union soldiers during the Civil War.

To reach a Nûñnë'hï townhouse, it was said, a Cherokee would have to follow the underside of a river uphill, like an inverse trail. And the Nûñnë'hï were known to have large townhouses beneath two particular locations: *Nikwasi* (an earthen mound still visible today in Franklin, North Carolina) and the rocky summit of *Jomeokee*, "the great guide," a lone Piedmont peak twenty miles northwest of Winston-Salem.

European settlers renamed "the great guide" something similar—"pilot"—because of its navigational value and came up with their own stories for the mountain. According to Roberson and Stewart, they thought it may have been the mountain where Noah's ark came to rest after the great flood of Genesis, and the legacy of that story can still be found in the names of nearby towns like Ararat and Mount Airy.

On an unseasonably warm day in early November, the forested dome of Pilot Mountain looms over U.S. 52 as I drive northwest. The rolling floodplains of the Yadkin River Valley on either side of the highway bring to mind the fertile French countryside. Signs for nearby vineyards add to the Western European flavor. From this angle a few miles away, it's easy to see why Pilot Mountain's iconic profile has been revered as a navigational guide for centuries and why it's one of the most-visited state parks in North Carolina today. The rounded, rocky summit resembles a massive stone observatory like El Caracol, the renowned Mayan ruin at Chichen Itza in Mexico.

But there are actually two peaks in Pilot Mountain State Park. The taller, celebrated one is Big Pinnacle (see color insert, figure 16), but just west of it, across a narrow saddle, lies the gentler-sloped Little Pinnacle, home of the park's best views—and largest parking lot. Like the peaks of Hanging Rock a few miles east (see chapter 6), Pilot Mountain's pinnacles are the only

Approaching Pilot Mountain from the south.

surviving members of the ancient Sauratown Mountain Range. Their sister mountains—made of softer schists and gneisses—were eroded away by wind, water and time. But along with the other Piedmont monadnocks, Pilot Mountain remains because of its erosion-resistant quartzite composition.

It's misleading, however, to think of Pilot Mountain and its sister monadnocks as the "last mountains standing" because even they have been severely diminished by the forces of nature over the past few hundred million years. It's better to think of Pilot Mountain and other quartzite formations as the leftover *foundations* of much, much taller mountains in the distant past. When the Appalachian orogeny was finished pushing up this ancient mountain chain 200 to 300 million years ago, they were as tall as the Alps. Time has reduced them to the gently rolling hills of the Piedmont, except for these durable, quartzite formations that were once nestled like matryoshka dolls inside the proto-Appalachians.

As I walk around the base of Pilot Mountain on a warm morning in early November, I notice several changes in the landscape occur when crossing from the southward-facing slopes to those on the north side. On the south, towering chestnut oaks dominate the canopy, with plenty of space between them, creating an open forest that feels both ancient and mysterious. In the fall, their golden leaves and high branches resemble the mythical realm of Lothlórien from *The Lord of the Rings* (see color insert, figure 17). Beneath the chestnut oaks, red bursts of sourwood and black tupelo compose the high understory, leaving the forest floor relatively open. The north-facing slopes of Pilot Mountain look a bit different. You'll still find plenty of chestnut oaks, but they're joined in the canopy by tall Virginia pines and other species of oak (red, white) and hickory. The understory is low and thick with mountain laurel, great laurel and Catawba rhododendron, creating an oak-heath forest.

Why the difference? Geologists call it "aspect." The cardinal direction that a mountain slope or hillside faces can have a major impact on its ecology and microclimate, thanks to the tilt of Earth's axis. Here in the northern hemisphere, the sun shines on south-facing slopes longer—and more directly—than it does on slopes with a northerly aspect, particularly in the winter when the north pole is tilted away from the sun.

As a result, south-facing slopes are typically warmer and drier in the United States, thanks to increased evaporation rates. North-facing slopes are cooler and wetter, since they spend more of the day in shadow. Thus, the northern slopes of Pilot Mountain are home to moisture-loving species of heath like rhododendron and mountain laurel.

As I approach the summit of Little Pinnacle, another shift in the landscape occurs, only now, elevation is the culprit instead of aspect. The lower slopes of the mountains are heavily forested, but in a few places, I can see the underlying rock, a dark metamorphic mix of gneiss and schist, peppered with bright shards of mica. Once I reach the summit of Little Pinnacle, however, the exposed stone is much lighter in color. Over 500 million years ago, these rocks were white sand on the beaches of Laurentia. When ancient continents collided in the Appalachian orogeny, the sand was heated and compressed into quartzite—the tough, erosion-resistant mineral that provided the Piedmont with its monadnocks like Pilot Mountain.

The forested, quartzite dome atop Pilot Mountain's Big Pinnacle is off-limits to visitors. It was sacred to the Cherokee as the mythical home of fairy-folk, and it is forbidden today to protect its flora and fauna. But Little Pinnacle is home to one of the most popular overlooks in North Carolina. Like the summit of Morrow Mountain (see chapter 11), it's dominated by a parking lot. When I reach the Little Pinnacle overlook around noon, it's about as quiet as a shopping mall on Black Friday. A short trail heads eastward and upward from the parking lot through quartzite outcrops, heath and table mountain pine until it reaches a fenced-in overhang with a spectacular view of Big Pinnacle and the surrounding Piedmont terrain.

Giant groups of children and teenagers sprint up the trail, pose for quick selfies at the overlook and sprint back down to the parking lot, gossiping

A dying tree covered in fungus at the top of Little Pinnacle.

about school and pop culture. They do not see the ravens and red-tailed hawks riding thermals over the saddle between peaks. They do not hear the crickets chirping in the heath. They don't see the hazy Winston-Salem skyline to the southeast or the imposing wall of the Blue Ridge Escarpment and the Eastern Continental Divide to the west. They don't see the bonsai-like specimens of table mountain pine clinging to the cliffs through storm, fire and ice. They don't see any of these things because no one has taught them how.

———◆———

TREES AND SHRUBS: bear oak, yellow birch, river birch, flowering dogwood, eastern redcedar, mountain laurel, sourwood, flame azalea, Catawba rhododendron, great laurel, black locust, American beech, chestnut oak, willow oak, northern red oak, black oak, dwarf witch-alder, black walnut, cucumber magnolia, bigleaf magnolia, white ash, American ash, Table Mountain pine, pitch pine, eastern hemlock, Virginia pine, Carolina hemlock, sycamore, green alder

SMALLER PLANTS: white snakeroot, silkgrass, Hercules club, Virginia snakeroot, mountain spleenwort, white snakeroot, Tennessee aster, green-and-gold, sweet Joe-pye-weed, rattlesnake hawkweed, sweet goldenrod, galax, beetle-weed, St. John's wort, yellow iris, dwarf iris, Virginia blue flag, American lily-of-the-valley, orange daylily, large-flower trillium, beargrass, turkey beard, wood anemone, wild columbine

FUNGI: fly agaric, the old man of the woods, cinnabar chanterelle, hedgehog fungus, honey mushroom, jack-o'-lantern mushroom, American Caesar's mushroom, cedar apple rust, witch's butter

MAMMALS: muskrat, raccoon, eastern cottontail, coyote, North American beaver, bobcat, northern river otter, white-tailed deer, southern flying squirrel, red fox, gray fox, black bear, striped skunk

REPTILES AND AMPHIBIANS: Appalachian seal salamander, Blue Ridge dusky salamander, southern leopard frog, copperhead, queen snake, corn snake, timber rattlesnake, northern spring peeper, upland chorus frog, eastern cricket frog, pickerel frog, red-spotted newt

BIRDS: broad-winged hawk, peregrine falcon, common raven, black-throated green warbler, worm-eating warbler, hooded warbler, snow goose, black culture, swallow-tailed kite, American kestrel, merlin, wild turkey, turkey vulture, Cooper's hawk, red-shouldered hawk, red-tailed hawk, eastern screech-owl, great horned owl, ruby-throated hummingbird, white-eyed vireo, Carolina chickadee, Carolina wren, purple martin, cliff swallow, barn swallow, tufted titmouse, eastern bluebird, pine warbler, yellow-rumped warbler, field sparrow, song sparrow

Chapter 13
CLIFFS NOTES

RAVEN ROCK

The park is a riot of wildflowers. The description on its website seems at first blush a little too enthusiastic, even gushy...But then you see the park, and it's all true...The place is gorgeously wild and overgrown, every turn in the trail opening upon a new discovery.
—*Philip Gerard,* Down the Wild Cape Fear

If you want to understand the Fall Line, drive forty miles southwest of Raleigh to Raven Rock State Park, where the Cape Fear River tumbles over a series of rocky ledges that halted European settlers in their tracks and massive cliffs of quartzite and gneiss line the southern banks, as tall as the tree canopy.

This is the dividing line between the metamorphic rock of the Piedmont and the sedimentary rock of the Coastal Plain. The cliffs and waterfalls are a result of the softer coastal rock below eroding faster than the tougher Piedmont rock above. When European settlers traveled up the Cape Fear River, they could take their boats no farther than the Fall Line, which is why Raleigh and Durham were founded on it, along with most of the major cities on the eastern seaboard.

Both Native Americans and Scottish settlers built fish traps here along the Cape Fear's cascades, and the waterfalls were a perfect source of energy for mills. Settlers would divert the rushing water to a waterwheel, which would then turn a massive millstone that would crush wheat grains into flour or maize into corn flour.

When Philip Gerard—an author and outdoorsman who teaches creative writing at UNC-Wilmington—passed through here on a kayak in his book *Down the Wild Cape Fear*, the topological transition was obvious: "In fifteen miles or so we have done the equivalent of falling off a four-story building."

Eventually, the Cape Fear Navigation Company built a series of locks and dams here that allowed boats to travel farther upriver, but they were destroyed by hurricanes, floods and the Civil War. Today, this stretch of the river flows unimpeded through the park and is popular with paddlers for its challenging rapids. But it's the floodplains on either side of the Cape Fear—as well as the cliffs and mesic slopes above them—that I came to Raven Rock to see.

"Raven Rock is often described as being a little piece of the North Carolina mountains set aside and carefully placed here between the Piedmont and Coastal Plain," says Superintendent Jeff Davidson. "Small mountain-like streams meander through the park, and guests often talk about how majestic the landscape is and how it reminds them of past hiking adventures in the mountains."

As I climb up and down the steep, north-facing slopes on the southern side of the park, I see what Davidson means. Thickets of Catawba rhododendron and mountain laurel blanket the understory here beneath towering chestnut oaks and longleaf pines. There's even an overlook of the Cape Fear River, several hundred feet above the floodplain below. But it's down there, among the sycamores and beeches and river birches, that I find the park's greatest ecological treasures.

The floodplains are threaded with smaller tributaries and, in the spring, are home to North Carolina's most impressive slate of wildflowers. Bright stars of bloodroot, alien tendrils of Carolina lily, the white bat's ears of Dutchman's breeches and other blooms of blue, purple, red and orange carpet the wet earth. Warblers and sparrows dart from tree to tree—just a few of the park's 183 species of bird. But not all of the wildlife here is so easy to see.

"A ranger and I were working late one night, trying to catch a poacher who'd been hunting and killing snakes at night to use for catfish bait," says Superintendent Davidson. "It was miserably hot; both of us were drenched in sweat and swatting at mosquitos. We were walking through the forest in total darkness, depending on the moon for light, when we suddenly saw something glowing in the leaf litter. Quickly, we realized we had uncovered a Phengodidae glowworm that had never been found in the park's forty-year history."

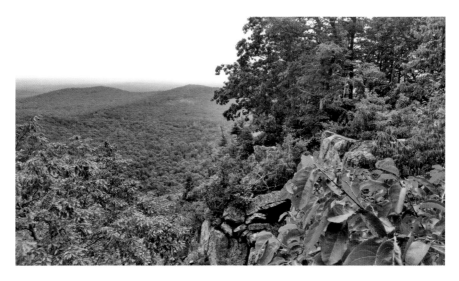

Figure 1. Looking southwest from the summit of Kings Pinnacle in Crowders Mountain State Park (chapter 4).

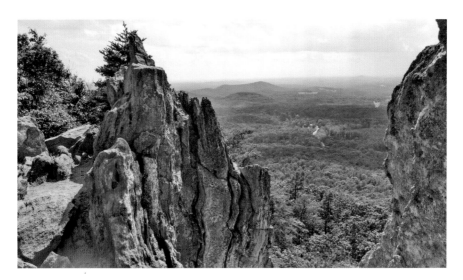

Figure 2. Vertical striations in the kyanite quartzite cliffs atop Kings Pinnacle in Crowders Mountain State Park (chapter 4).

Figure 3. Dwarf pines atop Kings Pinnacle in Crowders Mountain State Park (chapter 4).

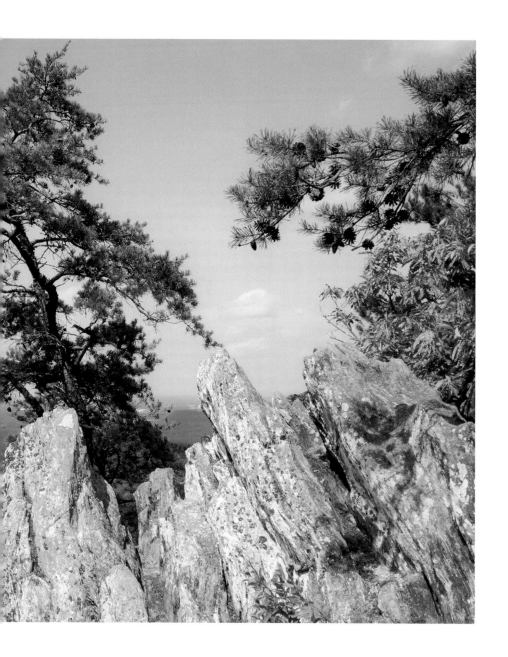

Figure 4. A five-lined skink (*plestiodon fasciatus*) on the Pinnacle Trail in Crowders Mountain State Park (chapter 4).

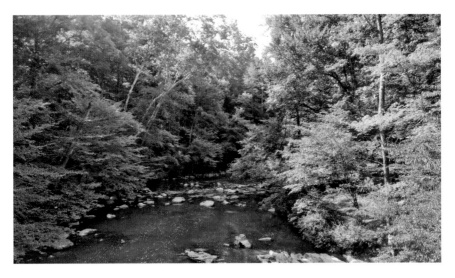

Figure 5. A deeply incised ravine at Eno River State Park (chapter 5).

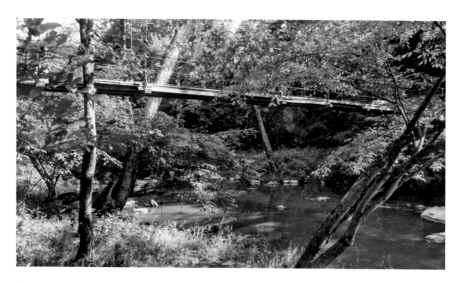

Figure 6. A pedestrian bridge over the Eno River (chapter 5).

Figure 7. Moore's Wall, Hanging Rock State Park (chapter 6).

Figure 8. Fall foliage in Cascades Creek Canyon, Hanging Rock State Park (chapter 6).

Figure 9. White-tailed deer, Hanging Rock State Park (chapter 6).

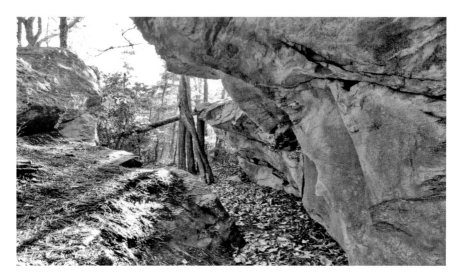

Figure 10. Cave-like outcrops of quartzite at Hanging Rock State Park (chapter 6).

Figure 11. Fall foliage on a ridgetop at Hanging Rock State Park (chapter 6).

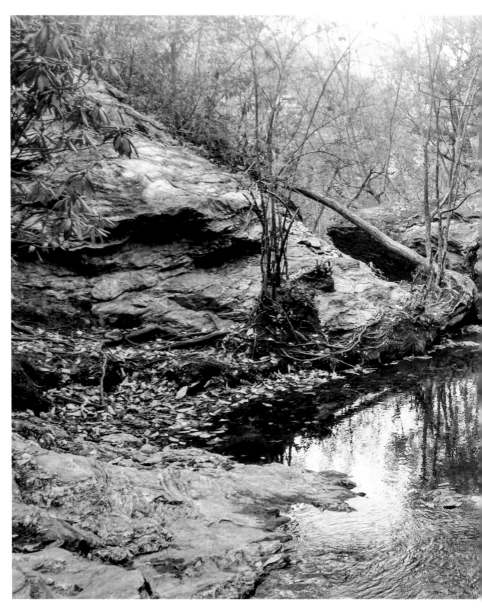

Figure 12. The pool beneath Cascade Creek Falls, Hanging Rock State Park (chapter 6).

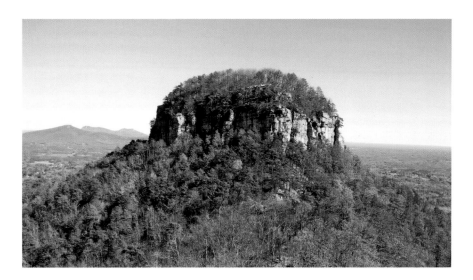

Opposite, top: Figure 13. Lake Norman State Park (chapter 8).

Opposite, middle: Figure 14. A seasonal rill covered with herbaceous growth, Lake Norman State Park (chapter 8).

Opposite, bottom: Figure 15. The restored homestead of Francis J. Kron, Morrow Mountain State Park (chapter 11).

This page, top: Figure 16. The iconic summit of Big Pinnacle, aka Pilot Knob, at Pilot Mountain State Park (chapter 12).

This page, bottom: Figure 17. A mixed hardwood cove at Pilot Mountain State Park (chapter 12).

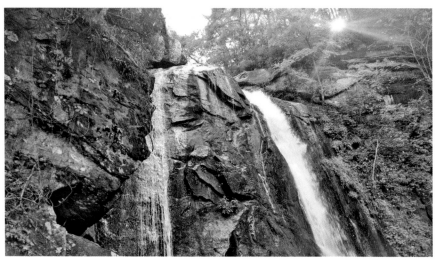

This page, top: Figure 18. A spray cliff community at High Shoals Falls, South Mountains State Park (chapter 14).

This page, bottom: Figure 19. High Shoals Falls, South Mountains State Park (chapter 14).

Opposite, top: Figure 20. Raven Rock, Raven Rock State Park (chapter 13).

Opposite, middle: Figure 21. Trees at the base of Raven Rock, Raven Rock State Park (chapter 13).

Opposite, bottom: Figure 22. A small, iced-over stream at William B. Umstead State Park (chapter 15).

Opposite, top: Figure 23. A dead tree covered in turkey tail fungus, William B. Umstead State Park (chapter 15).

Opposite, middle: Figure 24. A snow-covered pine rich with moss at William B. Umstead State Park (chapter 15).

Opposite, bottom: Figure 25. The icy shores of Falls Lake, Falls Lake State Park (chapter 16).

This page, top: Figure 26. A young successional forest on the shore of Jordan Lake in autumn (chapter 17).

This page, bottom: Figure 27. A sandy cove at Jordan Lake State Park (chapter 17).

Figure 28. Swift Creek at Hemlock Bluffs Nature Preserve (chapter 18).

Figure 29. Quartzite outcrops beneath chestnut oaks at the summit of Occoneechee Mountain (chapter 19).

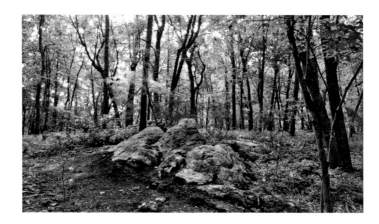

Figure 30. A tall grassland habitat at Pee Dee National Wildlife Refuge (chapter 20).

The Cape Fear River, as seen from the Raven Rock Overlook.

The glowworm the superintendent found is actually a beetle that looks like a creature straight out of *Starship Troopers* or a Lovecraftian nightmare. Completely unrelated to fireflies, female and larval glowworm beetles have their own bioluminescent organs that glow bright green or yellow and giant feathery antennae. Adult males don't do much, but the females are vicious predators that hunt millipedes and centipedes at night.

Of course, people don't come to Raven Rock to look for glowworms. They come to see Raven Rock itself.

Stretching for nearly a mile along the southern bank of the Cape Fear, a series of cliffs reaches a height of 150 feet at the end of the Raven Rock Loop Trail (see color insert, figure 20). Named for the ravens that once nested here (but don't anymore), the giant outcrops are a mix of quartzite and gneiss. The quartzite is lighter in color and fairly uniform in texture, whereas the gneiss alternates between light and dark bands flecked with mica. It's the quartzite that saved these cliffs from erosion, just like the monadnocks farther west in the Piedmont.

I descend a wooden stairwell to the base of the cliffs by the edge of the river. Walking on sandy soil beneath the towering stone walls, I'm reminded of the sandstone canyons of Starved Rock in Illinois, a few hours west of Chicago. The bluffs here were once just sandstone, too, but they were heated and compressed by the collision of continents 300 million years ago, the same orogeny that created the Appalachian Mountains.

A young successional forest atop the bluffs.

Luckily, Raven Rock isn't crawling with tourists and school groups in the spring like Starved Rock. But as I walk beneath the outcrops and slide my hand across bright specks of mica, a family of four passes by. Many naturalists and hikers prefer solitude, but the awe in this family's eyes as they gaze up at the cliffs is just as uplifting as the natural beauty along the banks of the Cape Fear.

TREES AND SHRUBS: brook-side alder, flowering dogwood, swamp cyrilla, mountain laurel, pink azalea, dwarf azalea, swamp azalea, Catawba rhododendron, Virginia willow, eastern redbud, sweet gum, tulip tree, red mulberry, white oak, Spanish oak, laurel-leaf oak, water oak, black oak, chestnut oak, long-leaf pine, eastern cottonwood, mapleleaf viburnum, dwarf pawpaw, pawpaw, mountain holly, American holly, river birch, American hop-hornbeam, American hazelnut, silky dogwood, black locust, southern magnolia, sweetbay magnolia, sugar maple, chalk maple, painted buckeye, southern basswood, American elm

SMALLER PLANTS: Carolina petunia, sweet Joe-pye-weed, big-headed aster, spotted jewel-weed, Spanish moss, Virginia spiderwort, southern lady fern,

Dutchman's breeches, Appalachian phacelia, crested dwarf iris, Carolina lily, atamasco lily, Indian-pipe, pink lady's-slipper, violet wood-sorrel, bloodroot, pink purslane, wild columbine, Carolina rose, southern arrowwood, smooth amaranth, sweet goldenrod, long-stalked aster, May apple, spiderflower, marsh dewflower, galax, Virginia creeper

FUNGI: hedgehog fungus, indigo milk mushroom, oyster mushroom, the old man of the woods, birch-bark bolete, fly agaric, reishi, yellow wart, witch's butter, turkey tail, false turkey tail

MAMMALS: white-tailed deer, red fox, northern river otter, Virginia opossum, big brown bat, eastern red bat, evening bat, tricolored bat, southern flying squirrel, North American beaver, coyote, gray fox, bobcat, striped skunk, raccoon, muskrat

AMPHIBIANS AND REPTILES: eastern cricket frog, green treefrog, pickerel frog, eastern spadefoot, Fowler's toad, marbled salamander, three-lined salamander, northern red salamander, eastern hog-nosed snake, eastern kingsnake, corn snake, red-bellied water snake, copperhead, eastern box turtle, northern fence lizard

BIRDS: bald eagle, American redstart, Swainson's warbler, prothonotary warbler, fox sparrow, great blue heron, dark-eyed junco, wild turkey, black vulture, turkey vulture, ruby-throated hummingbird, summer tanager, eastern screech-owl, green-winged teal, common goldeneye, northern bobwhite, green heron, black-crowned night-heron, osprey, Mississippi kite, Cooper's hawk, red-tailed hawk, merlin, purple martin, pine warbler, palm warbler, savannah sparrow, vesper sparrow, bobolink, orchard oriole, brown-headed catbird

Chapter 14

ANOTHER NEW WORLD

SOUTH MOUNTAINS

One forgets that there are environments which do not respond to the flick of a switch or the twist of a dial, and which have their own rhythms and orders of existence. Mountains correct this amnesia. By speaking of greater forces than we can possibly invoke, and by confronting us with greater spans of time than we can possibly envisage, mountains refute our excessive trust in the man-made. They pose profound questions about our durability and the importance of our schemes. They induce, I suppose, a modesty in us.
—*Robert Macfarlane*, Mountains of the Mind: Adventures in Reaching the Summit

South Mountains State Park lies thirty miles east of the Blue Ridge Escarpment. Geographically speaking, it's located in the Piedmont, but as I approach the South Mountains driving west on Interstate 40 near Morganton, one thing is immediately clear: there is nothing "piedmont" about them.

Towering over the flat plateau of Burke, Cleveland and Rutherford Counties, they could have been plucked from the Blue Ridge Mountains by a giant and placed here just yesterday. These are not the gentle monadnocks of Morrow Mountain or the sole peak of Pilot Mountain but a rugged range of steep mountains that make up the largest wilderness area in the North Carolina Piedmont. Seen from above, South Mountains State Park is a high, folded green blanket, separated from the Blue Ridge Mountains by a deep valley of patchwork-quilt farmland to the west and from the rest of the Piedmont by the Catawba River floodplain to the east.

Trees leaning over the Jacob Fork River to compete for sunlight.

The metamorphic rock that composes these mountains—a mixture of Toluca granite and pegmatite, threaded with veins of quartz and feldspar—was created by the same collision of ancient continents that created the entire Appalachian range. The rock here has eroded more slowly than the softer schist and gneiss in the valleys below. While not as lofty as the four-thousand- to five-thousand-foot peaks of the Blue Ridge, the highest point in the park (Buzzard's Roost) does reach three thousand feet.

It's one of the few places in the Piedmont where you can get a "classic" hiking experience, a three-tiered journey not unlike Joseph Campbell's monomyth—an exhausting quest from the familiar into the unknown and back again. The very structure of myths and stories—rising action, climax and falling action—forms the shape of a hike in the mountains.

On a midsummer afternoon, my wife, Erin, and I bring our dog, Sadie, deep into the South Mountains wilderness. At the High Shoals Falls trailhead, we can already hear the rushing of the Jacob Fork River, which has carved a steep lotic canyon into the mountainside. Almost immediately, we pass stone outcrops of schist and pegmatite flaked with mica and white veins of quartz. When we reach the steep, rocky banks of the Jacob Fork River, it's as if we've entered another world. A wet, green, vertical ecosystem.

Dark thickets of rhododendron and mountain laurel form walls on either side of the river. Above them, a canopy of bright green arches over the corridor like organic cathedral spandrels. The river tumbles and rushes

Liverworts, lichens and moss cover the boulders and tree trunks on the trail to High Shoals Falls.

downhill through a series of stone ledges and channels, while the trail climbs higher. Fairly soon, we cross a field of smooth, dark boulders along the banks of the river, some larger than our car. This particular boulder field was created by Hurricane Hugo in 1989, when torrential rains started a landslide on the rocky slopes above.

When we cross over the river to the opposite bank on a pedestrian bridge, I get a closer look at some of the cataracts. The river itself is filled with boulders from the trailhead all the way up to the falls, and most of them are covered with their own micro-ecosystems of moss, ferns and even small trees, meaning the stones have been here for a long time, unlike the more recent landslides. According to Stewart and Roberson's *Exploring the Geology of the Carolinas*, they've been sloughing off the cliffs at High Shoals Falls for centuries—at the rate of about one every ten to one hundred years—thanks to planar fractures or "joints" in the metamorphic stone that expand "when water seeps in and freezes, and when plant roots push their way in," until a boulder breaks off and tumbles downstream. I wouldn't want to be around when that happens, but once every century isn't very frequent, in human time. "In geologic time," Stewart and Roberson say, "a boulder every hundred years is practically an ongoing landslide of rocks."

After a few water breaks and dog-related detours, we reach the cliffs at the top of the trail, where High Shoals Falls gushes over a lip of stone and

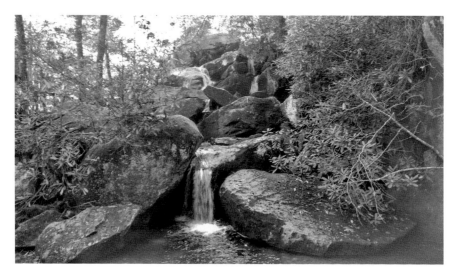

Cataracts on the Jacob Fork River, downstream of High Shoals Falls.

tumbles eighty feet to the pool below (see color insert, figure 19). The falls are beautiful, of course, but I spend more time exploring the stone walls nearby, coated with bright green vegetation. These "spray cliff communities" (see color insert, figure 18) are unique ecosystems found on rock faces within the splash zones of waterfalls. The faces are usually coated with mosses and liverworts. They're often confused as the same thing, but they aren't even related. Mosses are tiny, one-cell-thick leaves that reproduce via spores instead of seeds. Liverworts look and reproduce similarly but often have deep lobes in their leaves. In addition to these nonvascular species, small vascular plants like alumroot, night-shade, saxifrage and lithophytic ferns are often perched in the crevices of spray cliffs.

Above High Shoal Falls, no boulders impede the rest of our hike since the jointed cliffs now lie beneath us. As we travel farther away from the river, the forest transitions from the heath and hydric trees on the trail below to a fairly mature mixed hardwood forest dominated by oak and hickory. And our route is just one of twenty hiking trails that explore the park's other ecosystems, from the chestnut oak forests in the higher elevations to the acidic and rich cove forests in the folds of the mountains, as well as some pine-oak successional areas.

Virtually every major forest type you can find in the Blue Ridge Mountains can also be found within these eighteen thousand acres—

except for the spruce-fir forests atop Mount Mitchell and the Great Smoky Mountains—as well as the Piedmont's greatest variety of amphibians. Just keep your eye open for copperheads and timber rattlesnakes, the Piedmont's two venomous snakes.

———————◆———————

TREES AND SHRUBS: mountain laurel, Catawba rhododendron, Carolina rhododendron, flame azalea, sycamore, eastern hemlock, Carolina hemlock, shortleaf pine, Table Mountain pine, pitch pine, white pine, Virginia pine, tulip tree, fraser magnolia, sassafras, pignut hickory, mockernut hickory, bear oak, black oak, chestnut oak, scarlet oak, red oak, American beech, American chestnut, eastern redbud, sourwood, persimmon, flowering dogwood, alternate-leaf dogwood, sweet birch, river birch, American holly, pawpaw

SMALLER PLANTS: wood anemone, wild columbine, spotted wintergreen, bloodroot, cinnamon fern, yellow lady's-slipper, cranefly orchid, three birds orchid, Indian pipe, large-flower trillium, Carolina lily, dwarf iris, St. John's wort, wild hydrangea, Dutchman's breeches, Christmas fern, galax, zigzag spiderwort, cardinal flower, mountain bittercress, May apple, sweet goldenrod, silkgrass, green-and-gold, New England aster, mistflower, ginseng, jack-in-the-pulpit

FUNGI: the chicken of the woods, jelly ear, yellow-stalked puffball

MAMMALS: black bear, feral pig, eastern spotted skunk, striped skunk, bobcat, little brown myotis, northern myotis, evening bat, hoary bat, eastern red bat, big brown bat, silver-haired bat, tricolored bat, coyote, red fox, gray fox, North American beaver, eastern cottontail, Virginia opossum, white-tailed deer, smoky shrew, pygmy shrew, woodchuck

AMPHIBIANS AND REPTILES: Carolina mountain dusky salamander, Appalachian seal salamander, Blue Ridge two-lined salamander, Carolina spring salamander, northern dusky salamander, Blue Ridge spring salamander, white-spotted slimy salamander, Jordan's salamander, South Mountain gray-cheeked salamander, northern red salamander, pickerel frog, wood frog, southern leopard frog, northern green frog, Cope's gray treefrog, northern spring peeper, American bullfrog, eastern snapping turtle,

eastern box turtle, common musk turtle, eastern mud turtle, copperhead, timber rattlesnake, eastern six-lined racerunner, rough earth snake, green anole, scarlet kingsnake, corn snake, queen snake, northern water snake, mole kingsnake, eastern kingsnake, ring-necked snake

BIRDS: evening grosbeak, American goldfinch, house finch, purple finch, indigo bunting, common grackle, Baltimore oriole, eastern meadowlark, red-winged blackbird, blue grosbeak, northern cardinal, scarlet tanager, summer tanager, dark-eyed junco, pine warbler, yellow-throated warbler, yellow-rumped warbler, Cape May warbler, chestnut-sided warbler, black-throated blue warbler, Tennessee warbler, cedar waxwing, eastern bluebird, wood thrush, northern mockingbird, Carolina wren, winter wren, tufted titmouse, Carolina chickadee, eastern Phoebe, barn swallow, blue jay, raven, red-eyed vireo, pileated woodpecker, northern flicker, yellow-bellied sapsucker, red-bellied woodpecker, belted kingfisher, chuck-will's-widow, eastern whip-poor-will, common nighthawk, barn owl, eastern screech-owl, great horned owl, barred owl, American kestrel, red-tailed hawk, red-shouldered hawk, broad-winged hawk, sharp-shinned hawk, bald eagle, osprey, black vulture, turkey vulture, wild turkey, great blue heron, green heron, wood duck, hooded merganser, canvasback, blue-winged teal, lesser scaup

A STORIED FOREST

WILLIAM B. UMSTEAD

Out of this wood do not desire to go:
Thou shalt remain here, whether thou wilt or no.
I am a spirit of no common rate;
The summer still doth tend upon my state;
And I do love thee: therefore, go with me;
I'll give thee fairies to attend on thee,
And they shall fetch thee jewels from the deep,
And sing while thou on pressed flowers dost sleep;
And I will purge thy mortal grossness so
That thou shalt like an airy spirit go.
Peaseblossom! Cobweb! Moth! and Mustardseed!
—*(Titania) William Shakespeare,* A Midsummer Night's Dream

A name like "Umstead" doesn't really evoke natural beauty, but when I visit William B. Umstead State Park, a few miles north of downtown Raleigh, on a quiet morning in late February, the snow-covered forest is breathtaking. Walking along the trails on the northern end of the park, I'm struck by how hilly the topography is this close to the Coastal Plain. I pass through a relatively young mixed hardwood forest with lingering pines and cross over a small, winding creek with patches of ice (see color insert, figure 22).

The forest is unnaturally quiet, muted by the snow. Moss, lichens and fungi still thrive at the bases of trees, despite the deadening chill of winter (see color insert, figure 14). The farther I get from the visitor center, the

more the forest changes in composition, from younger successional forests dominated by pines to more mature hardwoods.

As I turn a corner on the trail, bright flashes of light up ahead bring me to a standstill. Through the trees, I see a tall, regal woman in a brilliant green dress, like some woodland fairy queen. Am I hallucinating? Have I stumbled upon Titania herself?

Strange things tend to happen here, and not just to me. Bob Davies has been a park ranger at Umstead for nearly three decades, and he's seen and experienced more than his share of the bizarre. "I noticed a strange car in my driveway one day," says Davies, who lives in a ranger residence in the park. Then he noticed someone had been "breaking out all of my windows, using the glass recyclables that were on the front porch. When I found her, she was naked. She was behind the house with a shovel. She said God told her that my house was where she was going to live. I told her to drop the shovel, which she did, and she asked me if she could get to her car to put her clothes on. Raleigh police took her to a nearby mental hospital for evaluation."

And that's not even the worst thing that's happened to Davies at Umstead. "I was building shelves with a sixteen-inch radial arm saw once and severed my left hand clean off. Luckily, another ranger drove up to wash her truck, so she called 911. She found my hand and placed it in a

A close-up of a dead tree completely covered in turkey tail fungus.

cooler. It happened so fast that my system blocked the initial pain, but it hurt on the way to the hospital. It took two doctors twelve hours in surgery at Duke to put it back on."

When I mentioned Bob's story to Greg Schneider, the current superintendent at Morrow Mountain State Park who used to work at Umstead, he smiled. "Oh, Bob. A while after that, he got his good hand bit by a copperhead."

My own Umstead story doesn't turn out nearly so dramatic. The Titania I encounter is no fairy queen, just a beautiful woman posing for a professional photographer by the side of the trail.

Since the park lies so close to one of the oldest and largest cities in the Carolinas, its forests were cut for timber and farmland hundreds of years ago. In 1945, 76 percent of Wake County was covered in farmland. But less than five decades later, that number had dropped to 22 percent. Urbanization is partly to blame, but Umstead offers another reason for the Piedmont's disappearing farmland.

The Umstead area was a canary of sorts during the Great Depression, when farmers tried to grow cotton and failed. After centuries of farming, logging and the resulting erosion, the soil within the present-day boundaries of the park was too poor to nourish crops. All the minerals and nutrients had been leeched away. But what was bad for farmers was good for the forests, which were allowed to reclaim the area after it was re-landscaped by the Civilian Conservation Corps and the Works Progress Administration in the 1930s and sold to the state for one dollar.

The next phase of the park's history is an ugly one. In the 1950s, it was segregated into two parks: one for whites (Crabtree Creek) and one for African Americans (Reedy Creek). A legacy of this division is still visible today: the southern and northern entrances of the park have no connecting through-road. Thankfully in 1966, over a decade after *Brown v. Board of Education* de-legislated segregation, and six years after the historic sit-ins in nearby Greensboro, the two parks were combined and named after the sixty-third governor of North Carolina, William B. Umstead.

Today, Umstead is one of the best places in the Piedmont to see ecological succession in action. Different corners of the park are progressing through different stages, from early pine-dominated forests where farmland was most recently abandoned to mixed hardwood forests with a scattering of pines. Several rocky creeks meander through the park as well, and their sloping riverbanks are home to heaths more commonly

The ridged, whorled bark of a tulip tree, aka yellow poplar or tulip poplar.

found in the Blue Ridge Mountains, like Catawba rhododendron and mountain laurel. Near these creeks, some stone ruins of abandoned gristmills remain.

But the most ecologically interesting part of the park is off-limits without a special permit: a fifty-acre grove of old-growth beech trees that are on the National Registry of Natural Landmarks. Beeches used to be more common in the Piedmont, but they take a long time to return to forests that were logged and farmed. Plus, farmers and other developers introduced a host of nonnative and invasive plants that still grow in the park today, taking up space in the understory and preventing some native species like beech from flourishing once again.

In other corners of the park lie dozens of downed trees, uprooted by Hurricane Fran in 1996 because their roots weren't large or extensive enough to keep them anchored in the earth. And yet from disaster comes new life, as their nutrients are gifted back to the soil and their absence in the canopy allows more sunlight to reach the forest floor, giving birth to a host of new plants. The cycle of death and rebirth and the march

of succession isn't always caused by man, but when it is, the forest takes much longer to recover. Which is too bad; a walk among the towering beech forests of yesteryear would be just as magical as Titania and Oberon's realm.

———◆———

TREES AND SHRUBS: summer grape, French mulberry, winged elm, American elm, slippery elm, sugarberry, bald cypress, tree-of-heaven, painted buckeye, red maple, chalk maple, sugar maple, black willow, silky willow, eastern cottonwood, common apple, peach, black cherry, Bradford pear, common pear, downy serviceberry, sycamore, Virginia pine, shortleaf pine, loblolly pine, primrose willow, green ash, white ash, fringe tree, black tupelo, red mulberry, white mulberry, common fig, southern magnolia, umbrella magnolia, crape myrtle, sassafras, pecan, pignut hickory, shagbark hickory, bitter-nut hickory, sweet gum, American witch-hazel, Virginia willow, post oak, willow oak, northern road oak, chinquapin oak, chestnut oak, swamp chestnut oak, white oak, American beech, black locust, eastern redbud, sourwood, mountain laurel, silky dogwood, flowering dogwood, persimmon, winter honeysuckle, Japanese honeysuckle, trumpet honeysuckle, river birch, brook-side alder, American holly, black holly, Chinese holly, pawpaw

SMALLER PLANTS: Carolina petunia, southern arrow-wood, American mistletoe, southern wood violet, broad beach fern, black nightshade, foamflower, American alumroot, lizard's tail, wild licorice, rambler rose, Carolina rose, windflower, wild columbine, common wintergreen, fringed loosestrife, northern maidenhair-fern, bloodroot, American water-lily, Indian-pipe, atamasco lily, Carolina lily, common daffodil, orange daylily, dwarf iris, St. Andrew's cross, St. John's wort, wild hydrangea, southern lady fern, galax, red morning-glory, Asiatic dayflower, spiderflower, cardinal flower, trumpet-creeper, May apple, spotted jewel-weed, sweet goldenrod, sweet Joe-pye-weed, fireweed, bull thistle

FUNGI: indigo milk mushroom, reishi, coker's amanita, Caesar's mushroom, the grisette, oyster mushroom, fly agaric, yellow morel, jelly rot, jack-o'-lantern mushroom, honey mushroom, pine spike, velvet earthstar, the black trumpet, cinnabar chanterelle, the old man of the woods, birch-bark bolete, flaming gold bolete

MAMMALS: American mink, white-tailed deer, common raccoon, black bear, red fox, gray fox, bobcat, northern river otter, coyote, muskrat, North American beaver, woodchuck, eastern mole, big brown bat, eastern red bat, evening bat, Virginia opossum

AMPHIBIANS AND REPTILES: red-spotted newt, Neuse River waterdog, northern dusky salamander, northern red salamander, Chamberlain's dwarf salamander, eastern red-backed salamander, southern two-lined salamander, spotted salamander, marbled salamander, Fowler's toad, eastern American toad, Cope's gray treefrog, eastern cricket frog, northern spring peeper, upland chorus frog, eastern narrow-mouthed toad, American bullfrog, pickerel frog, southern leopard frog, northern green frog, eastern painted turtle, eastern river cooter, eastern box turtle, spotted turtle, common musk turtle, copperhead, queen snake, eastern ringsnake, northern water snake

BIRDS: common grackle, brown-headed cowbird, northern cardinal, scarlet tanager, summer tanager, dark-eyed junco, swamp sparrow, eastern meadowlark, blue grosbeak, orchard oriole, pine warbler, yellow-throated warbler, prothonotary warbler, cedar waxwing, northern mockingbird, Carolina wren, winter wren, blue jay, raven, yellow-throated vireo, pileated woodpecker, red-bellied woodpecker, ruby-throated hummingbird, yellow-billed cuckoo, great horned owl, barred owl, northern flicker, American kestrel, red-tailed hawk, northern goshawk, red-shouldered hawk, bald eagle, osprey, turkey vulture, black vulture, green heron, great blue heron, American bittern, ahinga, double-crested cormorant, northern bobwhite, wild turkey, blue-winged teal, green-winged teal, American wigeon, wood duck, hooded merganser

PART III

Other Wild Places

A LAKE DIVIDED

FALLS LAKE

We went about 10 Miles, and sat down at the Falls of a large Creek, where lay mighty Rocks, the Water making a strange Noise, as if a great many Water-Mills were going at once. I take this to be the Falls of Neus Creek, called by the Indians, Wee quo Whom. *We lay here all Night.*
—*John Lawson,* A New Voyage to Carolina

Like all lakes in the North Carolina Piedmont, Falls Lake is man-made. Prior to 1981, the Neuse River tumbled over a series of rocky outcrops here, one of the many waterfalls along the Fall Line of North Carolina. But the river was prone to massive flooding that used to damage roads, farms and other nearby development. So beginning in 1979, the U.S. Army Corps of Engineers built an earthen dam along the river. Falls Lake is a twelve-thousand-acre reservoir behind that dam, and the "Falls of the Neuse" it was named after—the same that the English explorer John Lawson crossed in 1701 with his Native American guides—now lies submerged beneath the lake.

The lake actually sits atop a geological transition zone between two underlying terranes. The broader western side of the lake lies above the state's Triassic basin, an expanse of soft, flat sedimentary rock. Because of the shallow expanses of water on this side, you'll find wading birds in the spring and summer like great blue herons, green herons, black-crowned night-herons and even double-crested cormorants. In contrast, the eastern side of the lake is a string of narrow coves atop the Raleigh Belt, a more rugged mix of gneiss, schist and granite.

Falls Lake in the winter.

Both sides of the lake are home to an incredible number of birds. In the warmer months, shorebirds hunt for fish at the water's edge, and in the winter, gulls gather on the ice (see color insert, figure 25). Throughout the year, bald eagles soar over the water looking for food. Brian Bockhahn has been working at Falls Lake for nearly two decades as an interpretation and education specialist. "I've hiked every trail, paddled the entire length of the river, road biked a seventy-eight-mile loop around the entire lake and even swam across the widest part of the lake," he says. Bockhahn started a Christmas Bird Count in 1998, and he and his volunteers have counted 317 distinct species at Falls Lake, the most of any state park in the mountains, Piedmont or Coastal Plain.

"There used to be a landfill in northern Wake County off Durant Road," Bockhahn says, "so we had a resident gull population of over forty thousand birds. They would fly over to the landfill to feed and then return to the center of Falls Lake to sleep each night, causing a massive increase of bird droppings in the water." The landfill is gone now, and the gull population is back to normal. "The central lake area is wide and hosts numerous water birds in the winter, all in breeding plumage and working on mate selection. The lower lake is narrow with steep banks and has flora and fauna more representative of the mountains," Bockhahn says.

The Eno River (see chapter 5) flows directly into the western end of the lake, but unlike Eno River State Park, Falls Lake State Recreation Area is

A beaver lodge (center right) on Falls Lake.

not an uninterrupted buffer zone surrounding the entire lake but a series of seven patches of protected woodlands—mostly on the eastern side of the lake—that are currently in different stages of ecological succession. Some of the mesic southern banks with north-facing slopes are home to maturing mixed hardwood forests of magnolia, beech, oak, hickory and broad beech fern. Meanwhile, some of the floodplains are perfect examples of Piedmont bottomland forests filled with swamp chestnut oak. Other patches of pine-dominated forest are much younger, only a few decades into their recovery.

Eventually, the Mountains-to-Sea Trail will pass directly through here once the state-spanning project is complete. Right now, the thirty-four-mile Falls Lake Trail along the southern shores of the lake is one of many disconnected trails throughout North Carolina that will one day be united in an unbroken corridor that runs from the Tennessee border in the Smokies to the coast at Jockey's Ridge.

"The seasonal variations always keep things interesting," Bockhahn says. "Winter waterfowl, spring wildflowers, nesting birds, calling frogs, summer insects and fall monarch migrations in the thousands...I enjoy the diversity of the land and the diversity of the wildlife."

TREES AND SHRUBS: Virginia pine, loblolly pine, shortleaf pine, southern shagbark hickory, bitternut hickory, sand hickory, shagbark hickory, red hickory, pignut hickory, sweet pignut hickory, mockernut hickory, black walnut, scuppernong, American elm, sugarberry, American basswood, bald cypress, red maple, box elder, sugar maple, black willow, downy serviceberry, black cherry, Chickasaw plum, red chokeberry, black raspberry, common pear, sycamore, green ash, white ash, black tupelo, common fig, white mulberry, red mulberry, china-berry, southern magnolia, umbrella magnolia, tulip tree, crape myrtle, sassafras, spice bush, sweet gum, American witch-hazel, American beech, white oak, scarlet oak, water oak, post oak, black oak, willow oak, cherry-barked oak, swamp chestnut oak, black locust, honey-locust, sourwood, mountain laurel, hoary azalea, pink azalea, eastern redcedar, flowering dogwood, Japanese honeysuckle, trumpet honeysuckle, river birch, American hornbeam, coastal American hornbeam, Carolina holly, black holly, American holly, pawpaw, mapleleaf viburnum

SMALLER PLANTS: Virginia creeper, American mistletoe, broad beech fern, swamp rose, rambler rose, wild licorice, Carolina rose, wild columbine, fringed loosestrife, resurrection fern, bloodroot, cinnamon fern, Indian-pipe, atamasco lily, orange daylily, crested dwarf iris, St. John's wort, St. Peter's wort, galax, Christmas fern, cardinal flower, periwinkle, white heath aster, green-and-gold, Carolina petunia

FUNGI: crowded parchment, white cheese mushroom, turkey tail, gilded polypore, reishi, Caesar's mushroom, rubber-band polypore, thin-walled maze polypore, orange jelly cap

MAMMALS: American mink, muskrat, white-tailed deer, common raccoon, northern river otter, striped skunk, long-tailed weasel, red fox, gray fox, coyote, woodland vole, meadow vole, North American beaver, Virginia opossum, southern flying squirrel, Mexican free-tailed bat, eastern red bat, silver-haired bat, northern myotis, southeastern bat, least shrew

AMPHIBIANS AND REPTILES: American alligator, Neuse River waterdog, red-spotted newt, northern dusky salamander, eastern red-backed salamander, spotted salamander, marbled salamander, eastern spadefoot, three-lined salamander, eastern cricket frog, southern leopard frog, pickerel frog, northern spring peeper, upland chorus frog, green treefrog, squirrel treefrog, eastern American toad, Fowler's toad, American bullfrog, northern scarlet

Chapter 17
EAGLE'S REST

JORDAN LAKE

[B]efore they built the Jordan Lake Dam...we had floods. I remember hunting back here with my dad and finding parts of a liquor still up in a tree, finding all kinds of stuff, because you'd get a big fresh and it would pick it all up, and then the water would leave and it would be stuck in the trees...Back in '45, it went all the way up to the top of the railroad bridge. There was a car up there and goats...People are afraid of it.
—*David Avrette, in Philip Gerard's* Down the Wild Cape Fear

Jordan Lake is the slightly bigger brother of Falls Lake (see chapter 16), a fourteen-thousand-acre man-made reservoir created by an act of Congress after the massive Homestead hurricane floods of 1945. As with Falls Lake, the U.S. Army Corps of Engineers built a dam to control the floods in the 1970s. The lake lies near the end of the Haw River, just before it flows into the Cape Fear between Pittsboro and Raleigh.

Jordan Lake State Recreation Area consists of a few protected peninsulas and coves (see color insert, figure 27), primarily on the north shores of the lake. Literature on the site's ecology is virtually nonexistent, so my knowledge of the area is limited to my own field notes. The forests here are a mix of bottomland wetland forests in some of the northernmost fingers of the lake and upland mixed hardwoods and young pine-dominated forests. One of these younger stands of pine and sweet gum right along the lakeshore (see color insert, figure 26) is breathtaking during the late afternoon golden hours of autumn.

Just one section of the massive Jordan Lake.

But people don't come to Jordan Lake for the forests. They come for the eagles. "Bald eagles," says park ranger Steve McMurray. "Every year, the population has grown. Right now we're at a record high of thirteen active nests around the lake, one of the largest concentrations of bald eagles on the East Coast. When the dam releases water during the fall and winter months, over fifty eagles have been spotted perched downstream, waiting for the fish to surface."

Most people associate bald eagles with the Rocky Mountains and the Pacific Northwest, but in reality, they migrate seasonally throughout the entirety of North America. Their nests are the largest of any animals in the world, weighing up to one metric ton. Contrary to popular opinion, bald eagles—and all birds, for that matter—don't return to their nests every night to sleep. Birds build nests solely to protect their young and abandon them immediately after their offspring reach maturity. They sleep just about anywhere they can comfortably roost (some birds can even sleep with one eye open, while flying, thanks to a process called unihemispheric slow-wave sleep, which I'm pretty sure some of my undergraduate students have mastered, too).

Like ospreys, bald eagles primarily eat fish, swooping down over Falls Lake and grasping prey in their talons. But you may be surprised to hear that they also eat plenty of smaller waterbirds like herons, ducks and geese. Bald eagles are one of the greatest success stories of modern wildlife conservation in the United States, after nearly disappearing entirely during the latter half of the twentieth century and then being moved back to a "least concern" species in 2007.

Fallen leaves of sweet gum amidst pine needles.

Bald eagles aren't the only birds at Jordan Lake. "If you've never seen four to five thousand ring-billed gulls, come during the coldest months of winter, either early in the morning or just before sunset. It's an amazing sight," says McMurray. Six different stops on the North Carolina Birding Trail are located here, mostly on the western shores of the lake where songbirds like summer and scarlet tanagers, indigo buntings and blue grosbeaks abound in the mixed hardwood forests in the spring and summer.

Like every pocket of wilderness in the North Carolina Piedmont, Jordan Lake faces a variety of natural (invasive species) and man-made threats. "Pollution is the major threat to the lake," McMurray says. "The Haw River flows through many cities before flowing into Jordan Lake. Between construction, garbage dumping, erosion and fertilizers, you can imagine what makes it into the lake sometimes. But don't be alarmed. Jordan Lake is clean and safe for swimming, boating and kayaking." Despite his reassurances, I think I'll stick to watching bald eagles from the shore.

———— ◆ ————

TREES AND SHRUBS: sycamore, red maple, box elder, loblolly pine, shortleaf pine, Virginia pine, black willow, white poplar, American elm, winged elm, bald cypress, downy serviceberry, Chickasaw plum, black tupelo,

southern magnolia, crape myrtle, sassafras, pignut hickory, mockernut hickory, pecan, sweet gum, American witch-hazel, post oak, willow oak, swamp chestnut oak, scarlet oak, water oak, white oak, American beech, persimmon, eastern redcedar, flowering dogwood, Japanese honeysuckle, trumpet honeysuckle, American hornbeam, river birch, American holly, pawpaw, common water-willow

SMALLER PLANTS: Virginia creeper, Carolina rose, windflower, wild columbine, pink lady's-slipper, Indian pipe, atamasco lily, St. Andrew's cross, Carolina crane's-bill, hop sedge, red morning-glory, spiderflower, trumpet-creeper, cardinal flower, May apple, spotted jewel-weed, orange coneflower, marsh blazing star, marsh fleabane, green-and-gold, jack-in-the-pulpit, Carolina petunia

FUNGI: jelly ear, Caesar's mushroom, devil's urn, orange mock oyster, oyster mushroom, yellow pleated parasol, silky rosegill, hedgehog fungus

MAMMALS: white-tailed deer, northern river otter, common raccoon, gray fox, red fox, coyote, muskrat, North American beaver, eastern fox squirrel, woodchuck, eastern cottontail, eastern red bat, little brown myotis, Virginia opossum

AMPHIBIANS AND REPTILES: red-spotted newt, white-spotted slimy salamander, marbled salamander, spotted salamander, eastern cricket frog, Cope's gray treefrog, green treefrog, barking treefrog, squirrel treefrog, northern spring peeper, upland chorus frog, southern leopard frog, Fowler's toad, eastern narrow-mouthed toad, copperhead, corn snake, queen snake, northern water snake, eastern kingsnake, red-bellied water snake, eastern hog-nosed snake, eastern snapping turtle, eastern river cooter, eastern painted turtle, yellow-bellied slider, eastern six-lined racerunner

BIRDS: barn swallow, cliff swallow, fish crow, blue jay, red-eyed vireo, eastern kingbird, pileated woodpecker, northern flicker, yellow-bellied sapsucker, ruby-throated hummingbird, barred owl, great horned owl, eastern screech-owl, yellow-billed cuckoo, royal tern, Forster's tern, Caspian tern, herring gull, ring-billed gull, laughing gull, Bonaparte's gull, red phalarope, least sandpiper, sandhill crane, peregrine falcon, merlin, golden eagle, bald eagle, sharp-shinned hawk, red-tailed hawk, broad-winged hawk, osprey, turkey vulture, black vulture, green heron,

white ibis, black-crowned night-heron, little blue heron, tricolored heron, great white heron, great blue heron, great egret, snowy egret, brown pelican, great cormorant, double-crested cormorant, wild turkey, northern bobwhite, red-breasted merganser, hooded merganser, bufflehead, blue-winged teal, wood duck, black swan, tundra swan, mute swan, Canada goose, snow goose

Chapter 18

WOODLAND RELICS

HEMLOCK BLUFFS

*How long will it take to comprehend
the way blue wood smoke retains a spiral
while rising through hemlock boughs?*
—*George Ellison,* Permanent Camp

Fifteen thousand years ago, the Piedmont was a much cooler place.
Before the warm Holocene epoch we live in today, an ice age called the
Wisconsinan glaciation caused a massive ice sheet to descend on North
America as far south as present-day Indianapolis—the same glaciation
that caused a drop in sea levels and allowed for human migration across
the Bering Sea on a bridge of land between Siberia and Alaska. In those
days, the North Carolina Piedmont would have resembled the cooler, more
coniferous forests found at much higher elevations today, where towering
eastern hemlocks (*tsuga canadensis*) once thrived.

On current maps of the eastern hemlock's range in North America, you'll
see a large swath extending along the Appalachians—and a solitary speck
near the North Carolina Fall Line, hundreds of miles east of the rest. That
speck is Hemlock Bluffs Nature Preserve in the town of Cary, just west of
Raleigh, where a steep hemlock forest is frozen in time.

It's one of the smallest sites in this book by far at just 140 acres, yet it
contains a diversity of wildlife and topography that's just as impressive—if
not more so—than some of the larger sites. A series of bluffs along the
southern banks of Swift Creek has created three distinct ecosystems within
the preserve.

The western half atop the bluffs is an upland mixed hardwood forest dominated by chestnut oak, with its thickly ridged bark and giant acorns. As evidenced by the veins of quartz visible in some of the exposed stone, the bluffs exist today because they eroded more slowly than the surrounding rock. These higher elevations were the site of the preserve's heaviest farming and logging in the not-too-distant past. As a result, ecological succession is still ongoing; the oak-hickory forest is relatively mature in places, but you'll still find Virginia, loblolly, shortleaf and longleaf pines in the canopy for the next few decades, until disease and death make way for the inevitable hardwood takeover. Several nonnative species grow here, too, remnants of human interference before the preserve was set aside in 1976.

The eastern third of the preserve is a low-lying floodplain of Swift Creek (see color insert, figure 28). An alluvial forest of flood-tolerant river birch, sycamore and box elder is reclaiming old crop rows from the 1930s, as well as the site of an older gristmill on Swift Creek. Between February and June, these lowlands are carpeted with wildflowers. Lilies, irises, columbine and bloodroot put on quite a show. During spring migrations, the Swift Creek corridor is a vital stopping point for thousands of birds; according to Phillip Manning, more than 160 species have been spotted here.

But it's the preserve's third ecosystem that makes it so interesting and unique. Through sheer ecological luck, stands of eastern hemlock have somehow survived on the steep, north-facing slopes of the bluffs at the center of the preserve. As I've mentioned in earlier chapters, the geographical "aspect" of north-facing slopes in the northern hemisphere keeps them cooler and wetter than other landscapes, since they don't receive nearly as much sunlight. Eastern hemlock actually *prefers* partial shade and does perfectly fine in full shade, unlike a lot of other conifers, which could partially explain how these trees have survived here, so far away from their normal range in the Holocene epoch.

Hemlocks are conical evergreens—often tilted to one side like the tower of Pisa—with branches that sometimes look a little weighed down compared to perkier spruces and firs. Their needles are short and feathery, with small cones only an inch or so long. Their sturdy wood was often used in railroad ties and paper manufacturing. Another reason they're so uncommon throughout the Southeast is the mass infestation of hemlock wooly adelgid (*adelges tsugae*), a Japanese insect accidentally introduced in Virginia in the 1950s that has spread across eleven states on the East Coast. The adelgids suck the sap from hemlock branches, inject them with toxins and lay their eggs. Infected trees are easy to spot—look for tiny "cotton balls" (egg sacs)

The trunk of a mighty eastern hemlock.

on the underside of hemlock branches and for needles that have faded from deep green to a sickly gray.

Hemlocks aren't the only species thriving two hundred miles east of their typical habitat here on the cool, north-facing slopes above Swift Creek. Galax (*galax urceolata*), a shade-loving plant common in the Blue

A hillside covered in galax.

Ridge Mountains, bursts from the leaf litter beneath the hemlocks (see the image above). Its broad leaves exude a fairly unpleasant, skunk-like smell as the plant ages, but according to naturalist George Ellison:

> *Because its large shiny leaves assume beautiful colors in late fall—reds, bronzes, purples or browns—galax has been gathered commercially since the nineteenth century. Initially, entire families ventured into the mountains to collect them…Today, galax leaves are in high demand in the floral industry, both in America and Europe, because they are attractive, sturdy, and can be stored for months.*

Just don't remove any galax from Hemlock Bluffs; it's against the law. Harvesting is only allowed at specific sites in North Carolina, during a specific season, with a permit. To combat galax poaching in high-risk areas, the leaves are tagged with a traceable polymer.

———————◆———————

TREES AND SHRUBS: eastern hemlock, chestnut oak, Virginia pine, loblolly pine, shortleaf pine, longleaf pine, shagbark hickory, American elm, red maple, box elder, sycamore, green ash, white ash, black tupelo, southern magnolia, tulip tree, sassafras, American beech, white oak, sourwood,

mountain laurel, eastern redcedar, flowering dogwood, Japanese honeysuckle, trumpet honeysuckle, river birch, American hornbeam, American holly, mapleleaf viburnum

SMALLER PLANTS: galax, Virginia creeper, American mistletoe, Carolina rose, wild columbine, bloodroot, cinnamon fern, Indian-pipe, atamasco lily, orange daylily, crested dwarf iris, St. John's wort, Christmas fern, cardinal flower, periwinkle, green-and-gold, Carolina petunia

FUNGI: crowded parchment, white cheese mushroom, turkey tail, gilded polypore, reishi, Caesar's mushroom, rubber-band polypore, thin-walled maze polypore, orange jelly cap

MAMMALS: American mink, muskrat, white-tailed deer, common raccoon, northern river otter, striped skunk, red fox, gray fox, coyote, woodland vole, meadow vole, North American beaver, Virginia opossum, southern flying squirrel

AMPHIBIANS AND REPTILES: spotted salamander, marbled salamander, three-lined salamander, eastern cricket frog, southern leopard frog, pickerel frog, northern spring peeper, upland chorus frog, eastern American toad, Fowler's toad, American bullfrog, corn snake, scarlet kingsnake, copperhead

BIRDS: great horned owl, broad-winged hawk, red-headed woodpecker, northern bobwhite, chuck-will's-widow, indigo bunting, northern pintail, Mississippi kite, merlin, purple martin, northern cardinal, scarlet tanager, summer tanager, dark-eyed junco, pine warbler, yellow-throated warbler, prothonotary warbler, cedar waxwing, northern mockingbird, Carolina wren, pileated woodpecker, red-bellied woodpecker, ruby-throated hummingbird, yellow-billed cuckoo, barred owl, northern flicker, American kestrel, red-tailed hawk, red-shouldered hawk, turkey vulture, black vulture, wild turkey

Chapter 19

ICE AGE CROWN

OCCONEECHEE MOUNTAIN

About Three a Clock, we reach'd the [Achonechy] *Town, and the Indians presently brought us good fat Bear, and Venison, which was very acceptable at that time. Their Cabins were hung with a good sort of Tapestry, as fat Bear, and barbakued or dried Venison; no Indians having greater Plent of Provisions than these. The Savages do, indeed, still possess the Flower of Carolina, the English enjoying only the Fag-end of that fine Country.*
—*John Lawson*, A New Voyage to Carolina

An 867-foot monadnock looms over the town of Hillsborough, just west of Durham. At its base, the Eno River flows by on its way to Eno River State Park (see chapter 5) a few miles downstream. In the seventeenth century, the Occoneechee Indians built a settlement just downriver of the mountain's shadow. The English explorer John Lawson, who called it Achonechy Town, passed through in 1701 and was struck by the natural beauty and diversity of wildlife. While the Occoneechee Mountain State Recreation Area is fairly small today compared to other sites in this book, at just 190 acres, its summit and north-facing slopes are home to ecological treasures left over from a much earlier period in the Piedmont's history, just like Hemlock Bluffs (see chapter 18).

There is a stark contrast between the southern and northern slopes of the mountain. The dry, rocky southern side is more gradually inclined and home to a recovering forest of scarlet oak, blackjack oak, hickory and Virginia pine. In the northern hemisphere, south-facing slopes receive a lot of direct

sunlight throughout the year, even in the winter, leading to more xeric soils and plant species since rainwater evaporates more quickly.

The steeper northern slopes are moist and cool, thanks to their geological aspect. As I've discussed in earlier chapters, north-facing slopes in the northern hemisphere are typically home to more mesic plant communities thanks to the shade. On the trails that encircle the northern side of the mountain, you'll pass through dense thickets of Catawba rhododendron and mountain laurel, typically found much farther west in the Blue Ridge Mountains. These two evergreen *ericaceae* heaths look fairly similar out of bloom and often grow on the same cool slopes, but their flowers are easy to distinguish. The white and pink parasols of mountain laurel are much smaller and denser than the oversized pink and purple clumps of rhododendron blooms, which blossom in the spring.

Yet another easily mistaken heath native to Occoneechee and throughout the Appalachians is pink azalea (*rhododendron periclymenoides*). Some people even use "rhododendron" and "azalea" interchangeably, but while all azaleas are rhododendrons, not all rhododendrons are azaleas. Like the other heaths, pink azaleas are fairly easy to distinguish in mid-spring, thanks to their stringy pink flowers.

Other montane species like galax, sweet pinesap, wild sarsaparilla, purple fringeless orchid and witch alder thrive here, too. Bradley's spleenwort—an endangered species in several states but not in North Carolina—clings to some of the rocky outcrops. Nowhere else in the Triangle area will you find such a diversity of life. Very few sites this close to the Fall Line are home to montane species.

On the summit of Occoneechee Mountain, you'll find an overlook with a view of Hillsborough and the Eno River, but I challenge you to resist the urge to spend your time here looking somewhere else. Instead, turn back toward the mountain and you'll see why scientists believe this monadnock hasn't changed much since the last ice age fifteen thousand years ago, unlike the rest of the Piedmont.

Beneath a forest of chestnut oaks, flitting through the understory and exposed outcrops of quartzite (see color insert, figure 29), a large population of brown elfin butterflies (*callophrys augustinus*) calls the summit home. They're small, brown, relatively unremarkable *lycaenidae* butterflies, but their presence here, one hundred miles east of their typical range, tells ecologists that the summit and northern slopes of Occoneechee Mountain have remained frozen in time. Just like the north-facing slopes of Hemlock Bluffs (see chapter 18), the montane plants and insects here are remnants of the

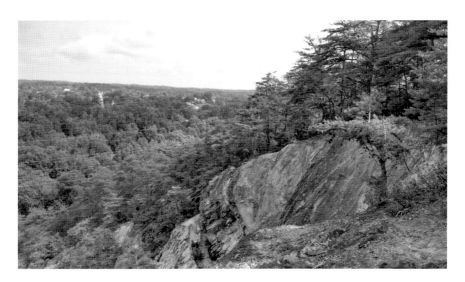

The view from the summit of Occoneechee Mountain, looking toward Hillsborough.

last ice age, when the Laurentide Ice Sheet descended on North America and plunged the Piedmont into a cooler, moister climate. Look for brown elfin butterflies feeding on wildflowers in May and June.

———— ◆ ————

TREES AND SHRUBS: chestnut oak, red maple, sugar maple, box elder, black willow, French mulberry, American elm, winged elm, black cherry, southern crabapple, sycamore, eastern hemlock, Virginia pine, loblolly pine, shortleaf pine, green ash, white ash, black tupelo, tulip tree, sassafras, pecan, pignut hickory, bitternut hickory, mockernut hickory, shagbark hickory, sweet gum, American witch-hazel, large witch-alder, American beech, post oak, black oak, northern red oak, scarlet oak, white oak, blackjack oak, mountain laurel, sourwood, Catawba rhododendron, pink azalea, eastern redcedar, stiff dogwood, flowering dogwood, silky dogwood, common elderberry, Japanese honeysuckle, American hornbeam, brook-side alder, American holly, mapleleaf viburnum, witch alder

SMALLER PLANTS: sweet pinesap, wild sarsaparilla, Bradley's spleenwort, purple fringeless orchid, marsh fern, broad beech fern, lizard's tail, early saxifrage, wild licorice, rambler rose, swamp rose, windflower, spotted

wintergreen, whorled loosestrife, broom-sedge, cinnamon fern, bloodroot, Catesby's trillium, Carolina lily, yellow trout-lily, dwarf iris, St. John's wort, St. Andrew's cross, Christmas fern, galax, cardinal flower, trumpet-creeper, May apple, sweet goldenrod

FUNGI: devil's urn, birch-bark bolete

MAMMALS: white-tailed deer, northern river otter, striped skunk, common raccoon, gray fox, red fox, muskrat, North American beaver, eastern red bat, woodchuck, Virginia opossum

AMPHIBIANS AND REPTILES: red-spotted newt, eastern red-backed salamander, pickerel frog, northern green frog, southern leopard frog, upland chorus frog, eastern cricket frog, Cope's gray treefrog, northern spring peeper, Fowler's toad, eastern American toad, American bullfrog, copperhead, banded water snake, ring-necked snake, eastern snapping turtle, yellow-bellied slider, red-eared slider, eastern box turtle, eastern painted turtle, northern fence lizard, common five-lined skink, ground skink

BIRDS: evening grosbeak, brown-headed cowbird, common grackle, red-winged blackbird, indigo bunting, northern cardinal, rose-breasted grosbeak, blue grosbeak, scarlet tanager, summer tanager, dark-eyed junco, prairie warbler, yellow-throated warbler, yellow-rumped warbler, pine warbler, black-throated blue warbler, chestnut-sided warbler, magnolia warbler, prothonotary warbler, cedar waxwing, European starling, eastern bluebird, Carolina wren, winter wren, tufted titmouse, Carolina chickadee, purple martin, blue jay, blue-headed vireo, northern flicker, pileated woodpecker, red-bellied woodpecker, yellow-bellied sapsucker, belted kingfisher, ruby-throated hummingbird, barred owl, great horned owl, killdeer, red-tailed hawk, sharp-shinned hawk, Cooper's hawk, broad-winged hawk, turkey vulture, black vulture, green heron, great blue heron, wild turkey, hooded merganser

Chapter 20
SANCTUARY

PEE DEE NATIONAL WILDLIFE REFUGE

[I]t occurred that the birds, whose twitters and repeated songs sounded so pretty and affirming of nature and the coming day, might actually, in a code known only to other birds, be the birds each saying "Get away" or "This branch is mine!" or "This tree is mine! I'll kill you! Kill, kill!" Or any manner of dark, brutal, or self-protective stuff—they might be listening to war cries.
—*David Foster Wallace,* The Pale King

Every year, millions of birds migrate between northern breeding grounds in the summer and southern wintering grounds, where food is still available, in the colder months. The arctic tern is the most ambitious migrator, summering in the Arctic and wintering in the Antarctic, but most migratory birds in North America travel somewhere between Canada and Mexico or the Caribbean, either wintering or stopping over in the United States on the way.

Amazingly, birds follow the same routes every migration, and there are four major ones in North America: the Pacific, Central, Mississippi and Atlantic Flyways. The Pee Dee National Wildlife Refuge (NWR) near the South Carolina border, a half hour south of Albemarle, is a vital stopping point for tens of thousands of migratory birds in the Atlantic Flyway every year. Some species spend the winter here in the refuge's wetlands, impoundments and ponds, while others continue farther south.

"We have approximately fifteen thousand ducks and geese and up to fourteen different waterfowl species on a good day in the winter," says Jeffrey

A wide expanse of former cropland.

Bricken, wildlife refuge manager at the Pee Dee. "I wish more people could enjoy them, but since we're a waterfowl sanctuary, the public isn't allowed in the refuge during the winter. Even our staff can only enter their habitats for surveys, maintenance and law enforcement."

Luckily, migrating waterfowl aren't the only birds you can see here, and many of them—over two hundred species total—are visible when the refuge is open to the public. Indigo buntings, northern bobwhites, ruby-throated hummingbirds, scarlet and summer tanagers, yellow-breasted chats, yellow-throated warblers, blue grosbeaks and American goldfinches fill the refuge with color and song. A few rare species like bald eagle and little blue heron can also be found.

In addition to the birds, Pee Dee NWR is one of the most strikingly beautiful places in the Piedmont in its own unique, austere way, with over 8,500 acres of diverse landscapes (see color insert, figure 30). "We're in a transition zone between the Piedmont and the Coastal Plain," says Bricken, "which allows for a blending of hardwood bottoms, upland pine, sandy soil, clay soil, hills, rock outcroppings and a wide variety of wildlife species."

About a third of the site is bottomland hardwood forest along the banks of the refuge's many waterways. Swamp chestnut oak, water oak and willow oak are prevalent here, along with some ashes and hickories, while the understory brims with holly, pawpaw, hornbeam and southern arrowwood.

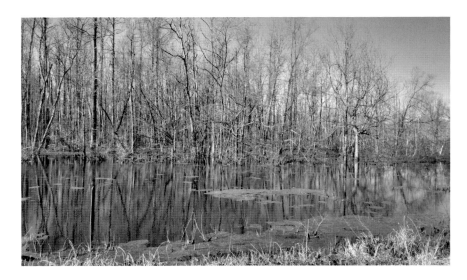

A wetland habitat.

The second-largest habitat (2,000 acres) is a successional mixture of hardwoods and pines, where loblolly and shortleaf pines take up about a quarter of the canopy. Another 1,500 acres is an upland forest of planted loblolly pines, along with sweet gum and a few stands of Virginia, longleaf and shortleaf pines in the more xeric parts of the forest. Refuge staff conduct regular prescribed burns to help restore the loblolly plantations back to a more natural, native forest, so don't be startled if you encounter blackened understories.

Finally, a few large open spaces are old fields and abandoned croplands, though the refuge does grow a small crop of corn and soybeans, which the birds feed on. It was established as a migratory bird sanctuary in 1963, but before that, a farmer named Lockhart Gaddy decided to make his property a Canada goose refuge in 1934. He started off with nine during his first winter, but by 1954, "Gaddy's Wild Goose Refuge" was home to more than ten thousand and had become a popular site for birdwatchers and waterfowl hunters. Canada geese don't flock here quite like they used to, but plenty of other waterfowl do.

———————•◆•———————

TREES AND SHRUBS: swamp chestnut oak, water oak, willow oak, cherrybark oak, white oak, sweet gum, loblolly pine, American beautyberry, buttonbush,

pawpaw, wild cherry, shortleaf pine, Virginia pine, longleaf pine, green ash, white ash, mockernut hickory, shagbark hickory, American hornbeam, American holly, devil's walking stick, southern arrowwood, meadow dolly

SMALLER PLANTS: yellow-fringed orchid, southern nodding trillium, Virginia meadow-beauty, goldenrod, false foxglove, fragrant water lily, American lotus, obedient plant, dogbane, atamasco lily, downy lobelia, swamp leather-flower, cutleaf toothwort, white baptista, rattlesnake master, trumpet creeper, pale persicaria, white milkweed, swamp sunflower

MAMMALS: white-tailed deer, bobcat, raccoon, opossum, red fox, gray fox, North American beaver, fox squirrel, eastern cottontail

AMPHIBIANS AND REPTILES: spotted salamander, American toad, pickerel frog, river cooter, eastern box turtle, green anole, copperhead

BIRDS: sandhill crane, barred owl, great horned owl, belted kingfisher, blue grosbeak, Canada geese, common snipe, gray catbird, great blue heron, great egret, green heron, indigo bunting, northern bobwhite, osprey, red-headed woodpecker, ring-necked duck, ruby-crowned kinglet, ruby-throated hummingbird, scarlet tanager, wild turkey, wood duck, wood thrush, yellow-breasted chat, yellow-throated warbler, mallard, green-winged teal, American wigeon, northern pintail, gadwall, ring-necked duck, snow goose, greater scaup, northern shoveler, redhead, canvasback, tundra swan, blue grosbeak, American goldfinch

Chapter 21

FOREST-IN-PROGRESS

UWHARRIE NATIONAL FOREST

A forest ecology is a delicate one. If the forest perishes, its fauna may go with it.
The Athshean word for world is also the word for forest.
—*Ursula K. Le Guin*, The Word for World Is Forest

The Uwharrie National Forest is a very young successional forest atop an ancient, ruined mountain range, the only remnants of which are the monadnocks just west of the forest, on the other side of the Yadkin–Pee Dee River at Morrow Mountain State Park (see chapter 11). The fifty-one-thousand-acre forest named for that mountain range lies mostly in Montgomery County but stretches into Randolph and Davidson Counties as well.

Over the past few decades, locals, hikers and bikers have reported sightings and signs of the eastern cougar (*puma concolor couguar*), believed by many wildlife specialists to be extinct. But before you go looking for cougars, the U.S. Fish and Wildlife Service officially named the eastern cougar extinct in 2011, and here's Clemson University's research wildlife biologist Robert L. Downing on the rumors:

> *National Forest personnel in North Carolina enlisted the help of David Lee, of North Carolina State Museum, to compile and investigate cougar reports statewide and Dick Brown of the University of North Carolina at Charlotte to do a detailed analysis of reports from Uwharrie National Forest. Both investigators recommended further*

field searches for sign, and a professional cougar hunter from Colorado
was brought in for a month in 1977 for this purpose. My own study
was organized after this effort failed to provide positive evidence of the
presence of cougars.

The site was purchased by the state in 1931 and established as one
of North Carolina's four national forests—along with the Pisgah and
Nantahala forests in the mountains and the Croatan forest on the Coastal
Plain—by President John F. Kennedy in 1961. Before that, Native
Americans lived here for at least twelve thousand years, and then a gold
rush in 1799, the first major one in the new United States, brought settlers
in droves. Abandoned quarries, mines, settlements and cemeteries can still
be found in the forest today.

About twenty thousand acres is a recovering timber plantation, filled
with dense stands of loblolly pine. In the twentieth century, loblolly pines
were very popular for timber, but they aren't native to the Uwharrie area.
Another twenty thousand acres is a xeric oak-hickory forest. White oak, post
oak, southern red oak, shagbark hickory and pignut hickory dominate the
canopy, along with white and green ash, eastern redbud and winged elm,
above an understory of northern oak grass, broomsedge, little bluestem,
deerberry, farkleberry and whorled milkweed.

But the forest is changing, every year and every day. The major goals
of the National Forest Service over the next few decades is to promote the
process of ecological succession toward a more natural forest, away from
loblolly stands and nonnative invasive species and toward native forest types.
To give nature a helping hand at thinning out loblollies and encouraging
other kinds of growth, you'll see lots of prescribed burns and downed trees.
The plan is to restore one hundred acres of longleaf and two hundred acres
of oak and hickory every year while creating canopy gaps to encourage
understory growth and removing one hundred acres of nonnative trees and
plants every year as well.

The largest forest type they're restoring is a more mesic oak-hickory
forest on the site's lower slopes, with white oak, northern red oak, black oak,
mockernut hickory, shagbark hickory, red hickory, red maple, sweet gum and
tulip poplar above an understory of huckleberry and rattlesnake plantain.
A few mesic pockets do exist today, but they pale in comparison to the vast
loblolly plantation. The forest service is also restoring xeric oak forests on the
site's higher elevations, with a patchwork canopy of chestnut oak, post oak,
southern red oak and pignut hickory.

The Uwharrie Trail.

Finally—because there's nothing wrong with pines, per se—the forest service is turning seven thousand acres into an open longleaf pine woodland, dappled with shortleaf pines and oaks but free from loblolly. The understory will be sparse but home to blueberry, New Jersey tea, chinquapin and hopefully the endangered Schweinitz's sunflower (*helianthus schweinitzii*), which needs plenty of sunlight to thrive.

———◆———

TREES AND SHRUBS: loblolly pine, shortleaf pine, longleaf pine, Virginia pine, white ash, pignut hickory, eastern redbud, winged elm, shagbark hickory, southern red oak, post oak, white oak, blackjack oak, hillside blueberry, New Jersey tea, common chinquapin, sweet gum, tulip poplar, sycamore, river birch, American beech, mountain laurel, red maple

SMALLER PLANTS: Schweinitz's sunflowers, deerberry, farkleberry, whorled milkweed, northern oak-grass, broom-sedge, little bluestem, splitbeard bluestem, Virginia goat's-rue, yellow Indian-grass, poverty oat-grass, silky oat-grass, galax, wood anemone, green-and-gold, yellow yam, black cohosh, bloodroot, maidenhair fern, Christmas fern

BIRDS: pileated woodpecker, brown-headed nuthatch, Acadian flycatcher, northern bobwhite, scarlet tanager, wood thrush, indigo bunting, blue grosbeak, red-headed woodpecker, red-bellied woodpecker, American redstart, prothonotary warbler, hooded warbler, summer tanager, eastern kingbird, turkey vulture, black vulture, wild turkey

Chapter 22
CITY ESCAPES

CHARLOTTE, TRIAD AND TRIANGLE

Sometimes it is safer to read maps with your feet.
—*Kelly Link*, Stranger Things Happen

Almost all the sites I've covered in earlier chapters are only a thirty- to sixty-minute drive from the Piedmont's major urban areas, but sometimes it's nice to escape into a smaller wilderness even closer to home. What follows is by no means an exhaustive list but includes my own personal favorites.

Near Charlotte, the **LATTA PLANTATION NATURE CENTER AND PRESERVE** is a 1,300-acre wilderness area just north of city limits in Huntersville, on the shores of Mountain Island Lake. Once a cotton plantation owned by James Latta at the height of slavery in the Southeast, the site has been slowly returning to a more natural state over the past few decades. Young upland and bottomland hardwood forests dominate, but some areas are still in the early, pine-dominated stages of succession; a Piedmont prairie restoration is also underway in the preserve's eastern acres. Part of the National Audubon Society's larger Mountain Island Lake IBA (Important Bird Area), you'll find plenty of migratory songbirds in the summer and waterfowl in the winter. I've encountered several peregrine falcons and red-shouldered hawks on the dog-friendly trails. The preserve is also the home of the **CAROLINA RAPTOR CENTER**, a one-of-a-kind outdoor museum featuring injured eagles, hawks, ravens, falcons, merlins and other birds of prey that are being nursed back to health or can no longer survive in the wild.

Welcome to the Carolina Raptor Center.

Just twelve miles north of downtown, the **UNC-CHARLOTTE BOTANICAL GARDENS** are a natural treasure of native and exotic species. The northern side is a landscaped, ornamental garden of Japanese maples, Chinese snowball viburnum and a host of smaller, colorful vascular plants, along with traditional Japanese garden architectural features like bridges, stone lanterns, a covered patio and an iconic circular gateway (see the image on the next page). The southern side of the gardens is a larger, more natural forest of native oaks, hickories and pines towering over rhododendron cultivars that burst with color in April. I walk through both sides of the gardens every week in between the classes I teach at UNC-Charlotte and always encounter dozens of songbirds. Northern cardinals, cedar waxwings, Carolina wrens, Carolina chickadees, tufted titmice and sparrows are the most common, but I've also seen yellow-bellied sapsuckers, red-tailed hawks and red-shouldered hawks.

Also on the northern outskirts of Charlotte, the **U.S. NATIONAL WHITEWATER CENTER** is perched on the banks of the Catawba River. Its trails aren't exactly peaceful (you'll walk beneath a few ropes courses), but it's one of the most unique outdoor recreation centers in the Southeast, with hiking and biking trails, climbing walls and the challenging man-made whitewater channel, not to mention a restaurant, gift shop and outdoor concert series. Even closer to downtown, the **RIBBONWALK NATURE PRESERVE** is nearly two hundred acres of mid-successional forest just four miles from the city

The Asian Garden at the UNC-Charlotte Botanical Gardens.

center. The recovering farmland and pine plantations now feature plenty of maturing hardwoods, including a large grove of American beech at the northern end of the preserve.

On the southern side of the Charlotte area, the **DANIEL STOWE BOTANICAL GARDEN** is known for its handsomely landscaped, themed gardens full of ornamental flowering plants, as well as its well-appointed, glassed-in Orchid Conservatory. It also features a nature trail that meanders through mixed hardwoods and a recovering meadow that skirts the northern edge of Lake Wylie.

A little farther south on another peninsula jutting into Lake Wylie, the **McDOWELL NATURE PRESERVE** is a 1,100-acre blend of mixed hardwood forest, pine and restored Piedmont prairie (where you can find the federally endangered Schweinitz's sunflower). Wildflowers and birds abound in the warmer months, and while the lakeshore trails betray the heavily suburban nature of Lake Wylie's other banks, the inner parts of the preserve are quiet, verdant and worth visiting.

In the Triad area, the **PIEDMONT ENVIRONMENTAL CENTER** in High Point is a 376-acre plant and wildlife preserve with eleven miles of hiking trails and educational facilities. The forest here is a mix of hardwood patches and successional pine, along with a few hydric lakeside areas. Also in Gibson County, **HAGAN-STONE PARK** is a more manicured, 409-acre park with woods and open spaces, eight miles of hiking and biking trails and paddling rentals in the summer.

Near Winston-Salem, the **REYNOLDA GARDENS OF WAKE FOREST UNIVERSITY** are a beautifully landscaped series of formal gardens and greenhouses, not unlike the Daniel Stowe Botanical Garden near Charlotte but quite a bit larger. Trails winding through the surrounding woods and meadows are one of the best places in the Triad to watch for birds. It's on the North Carolina Birding Trail, and volunteers have spotted over two hundred species here, including bald eagle, blue grosbeak, bobolink, cerulean warbler, great egret, merlin, osprey, purple martin, scarlet and summer tanager and yellow-crowned night-heron. Nearby, **HISTORIC BETHABARTHA PARK** is best known as a historic cultural site celebrating the state's first Moravian settlement in 1753, but it also features a 183-acre wildlife preserve with twenty miles of nature trails, two wetland observation decks and a beaver pond.

In the Triangle area, the **CARL ALWIN SCHENCK MEMORIAL FOREST** at North Carolina State University in Raleigh—nicknamed "the Schenck"— is a 245-acre mid-successional forest used by the university for teaching and research. If you want to see the kind of forestry management that's going on to restore native, natural communities to the Uwharrie National Forest (see chapter 21), take the Frances L. Liles Trail. Pines abound, from the common loblolly, shortleaf, longleaf and Virginia to slash, pitch, pond and spruce pine. Also at NC State, the **J.C. RAULSTON ARBORETUM** has one of the largest collections of landscape plants in the country: 6,401 taxa, 46,196 plants and 10,133 plantings. Though not particularly wild, the sheer diversity of plant life is worth a trip, particularly since they've been adapted to thrive in the Piedmont.

Near Durham, **DUKE FOREST** is Duke University's own seven-thousand-acre teaching and research forest. If you only have time to visit one site in the Triangle area, make it this one (though it pains the Tar Heel in me to say so). Threaded with walking trails, the forest is an exemplary example of ongoing ecological succession. The most widespread cover is Virginia, shortleaf and loblolly pine in the drier and younger parts of the forest, only

just recovering from human activity in the twentieth century. More mesic zones are home to mixed hardwoods, predominately oak-hickory but also post oak, white oak and blackjack oak stands on some xeric, south-facing slopes. The lowest elevations are home to lowland or bottomland forest, with species cover depending on how hydric the soil is. Birch and sycamore reign in the floodplains; beech, maple and oak thrive in well-drained areas; and tulip tree, sweet gum and ash survive in the drier, low-lying areas.

In and around Chapel Hill, the **NORTH CAROLINA BOTANICAL GARDEN** owns several distinct ecological treasures. The most popular site is the Display Gardens and Education Center, but the Piedmont Nature Trails just downhill are much wilder. Trails thread through eighty-eight acres of hardwoods and pine stands that are particularly beautiful in the spring, when trout lilies and trilliums bloom, along with dogwoods and eastern redbuds, though the hardwood communities offer their own color in the fall.

Some of the North Carolina Botanical Garden's other sites are so rare and sensitive—like the Mason Farm Biological Reserve and the Stillhouse Bottom Preserve—that they're closed to the public. But several on-campus sites at the University of North Carolina are worth visiting, including Battle Park, Forest Theatre and my own personal favorite, Coker Arboretum. Bordered by an iconic pergola covered in flowers and vines, the arboretum was founded in 1903 by UNC's first botany professor, Dr. William Chambers

The University of North Carolina campus, lined with massive oaks and arboretum-style plaques.

Coker, who turned a five-acre bog into an outdoor museum of trees and shrubs native to North Carolina, along with some East Asian species that he was fond of.

Of course, the historic parts of UNC's Chapel Hill campus are also arboretums in their own right; most of the towering oaks, beeches, maples, poplars, magnolias and other species are clearly labeled by metal plaques at their bases. Make sure to visit the Davie Poplar, a three- to four-century-old tulip poplar on the McCorkle Place lawn near Morehead Planetarium. According to legend, the founder of the university, William Richardson Davie, choose to build the campus around this tree after eating lunch beneath it one day in 1650, and if a couple kisses on the stone bench beneath it, they're destined to marry.

BIBLIOGRAPHY

Alderfer, Jonathan K. *National Geographic Field Guide to Birds: The Carolinas.* Washington, D.C.: National Geographic, 2005.

Campbell, Joseph. *The Hero with a Thousand Faces.* New York: Pantheon, 1949.

Charlotte Observer. "A Year after Duke Spill, Work to Do." Editorial. February 2, 2015. www.charlotteobserver.com/opinion/editorials/article9499505.html#.VM_Samh4oYl.

Clarke, Stephen, and J.T. Nowak. "Southern Pine Beetle." U.S. Department of Agriculture, Forest Service, April 2009. www.fs.usda.gov/Internet/FSE_DOCUMENTS/fsbdev2_042840.pdf.

Coe, Joffre Lanning, and Thomas D. Burke. *Town Creek Indian Mound: A Native American Legacy.* Chapel Hill: University of North Carolina Press, 1995.

Copulsky, Steve. "A 'Peak' of Reflection." PlanCharlotte.org. UNC-Charlotte Urban Institute. December 2, 2013. plancharlotte.org/story/crowders-mountain-peak-reflection.

Downing, Robert L. "The Search for Cougars in the Eastern United States." *Cryptozoology* 3. International Society of Cryptozoology, 1984.

Ellison, George, and Elizabeth Ellison. *Permanent Camp: Poems, Narratives, and Renderings from the Smokies.* Charleston, SC: The History Press, 2012.

Frankenberg, Dirk. *Exploring North Carolina's Natural Areas: Parks, Nature Preserves, and Hiking Trails.* Chapel Hill: University of North Carolina Press, 2000.

Gerard, Philip. *Down the Wild Cape Fear: A River Journey through the Heart of North Carolina.* Chapel Hill: University of North Carolina Press, 2013.

Godfrey, Michael A. *A Sierra Club Naturalist's Guide to the Piedmont.* San Francisco: Sierra Club, 1980.

Guin, Ursula K. *The Word for World Is Forest*. New York: Berkley Publishing, 1972.

Haskell, David George. *The Forest Unseen: A Year's Watch in Nature*. New York: Penguin, 2012.

Henderson, Bruce. "Proposed Permits to Allow Duke Ash Pond Leaks." *Charlotte Observer*, March 9, 2015. www.charlotteobserver.com/news/local/article13140950.html.

Hvistendahl, Mara. "Coal Ash Is More Radioactive Than Nuclear Waste." *Scientific American*, December 13, 2007. www.scientificamerican.com/article/coal-ash-is-more-radioactive-than-nuclear-waste.

Krohn, Leena. *Tainaron: Mail from Another City*. N.p.: Cheeky Frawg Books, 2012.

Kuenzler, Edward J. *Time and the Piedmont: A History of Its Natural Systems*. Chapel Hill, NC: Chapel Hill, 2004.

Lawson, John. *A New Voyage to Carolina Containing the Exact Description and Natural History of That Country; Together with the Present State Thereof; and a Journal of a Thousand Miles, Travel'd Thro' Several Nations of Indians, Giving a Particular Account of Their Customs, Manners, Etc.* London, 1709.

Link, Kelly. *Stranger Things Happen*. Brooklyn, NY: Small Beer, 2001.

Lund, Nicholas. "Wait, Where Do Birds Really Sleep?" *Slate*, January 23, 2014. www.slate.com/blogs/wild_things/2014/01/23/where_do_birds_sleep_roosting_in_nests_water_flocks_cavities.

Macfarlane, Robert. *Mountains of the Mind*. New York: Pantheon, 2003.

McGrath, Gareth. "McCrory Aims to Put All N.C. Attractions Under One Department." StarNewsOnline. February 19, 2015. www.starnewsonline.com/article/20150219/ARTICLES/150219666?p=2&tc=pg.

McShane, Chuck. "A History of Lake Norman." *Charlotte Magazine*, August 2013. www.charlottemagazine.com/Charlotte-Magazine/August-2013/Lake-Effect/?cparticle=2&siarticle=1.

Minnick, Beau. "Rangers: Don't Take Wildlife from Umstead Park." WRAL.com. June 4, 2009. www.wral.com/news/local/story/5280140.

Mooney, James. *Myths of the Cherokee*. New York: Dover Publications, 1995.

Muir, John. *Nature Writings: The Story of My Boyhood and Youth; My First Summer in the Sierra; The Mountains of California; Stickeen; Selected Essays*. New York: Literary Classics of the United States, 1997.

"N.C. Division of Parks and Recreation." Ncparks.gov. ncparks.gov/Visit/main.php.

Nitze, Henry Benjamin Charles. *Iron Ores of North Carolina: A Preliminary Report. [With Maps]*. N.p., 1893.

The North Carolina Birding Trail: Piedmont Trail Guide. Chapel Hill: University of North Carolina Press, 2008.

Phillips, Ida, and Bill Pendergraft. *North Carolina State Parks: A Niche Guide.* Chapel Hill, NC: Niche Publishing, 2007.

Pinney, Thomas. *The Makers of American Wine: A Record of Two Hundred Years.* Berkeley: University of California Press, 2012.

Powell, William S. *North Carolina: A History.* Chapel Hill: University of North Carolina Press, 1988.

Rash, Ron. *Nothing Gold Can Stay: Stories.* N.p.: Ecco, 2014.

Stewart, Kevin G., and Mary Roberson. *Exploring the Geology of the Carolinas: A Field Guide to Favorite Places from Chimney Rock to Charleston.* Chapel Hill: University of North Carolina Press, 2007.

Tolkien, J.R.R. *The Fellowship of the Ring: Being the First Part of the Lord of the Rings.* Boston: Mariner/Houghton Mifflin Harcourt, 1954. Reprint, 2012.

———. *The Two Towers: Being the Second Part of the Lord of the Rings.* Boston: Mariner/Houghton Mifflin Harcourt, 1954. Reprint, 2012.

"Under Lake Norman." Davidson College Archives and Special Collections. sites.davidson.edu/archives/community/under-lkn.

VanderMeer, Jeff. *Acceptance.* N.p.: FSG Originals, 2014.

———. *Annihilation.* N.p.: FSG Originals, 2014.

Wegmann, K.W., R.Q. Lewis and M.C. Hunt. "Historic Mill Ponds and Piedmont Sream Water Quality: Making the Connection Near Raleigh, North Carolina." In *From the Blue Ridge to the Coastal Plain: Field Excursions in the Southeastern United States: Geological Society of America Field Guide 29*, edited by M.C. Eppes and M.J. Bartholomew. Boulder, CO: Geological Society of America, 2012, 93–121.

INDEX

ABOUT THE AUTHOR

 Adam Morgan is an author, educator and award-winning screenwriter from North Carolina who lives in Chicago. His writing has been featured in the *Denver Post*, *Bookpage* and elsewhere. He has taught writing, screenwriting and English as an adjunct professor at Montreat College and the University of North Carolina–Charlotte. He is a member of the Sierra Club and the Nature Conservancy.

Visit us at
www.historypress.net
...
This title is also available as an e-book